G R A P H I T E

CONCEPT DRAWING | ILLUSTRATION | URBAN SKETCHING

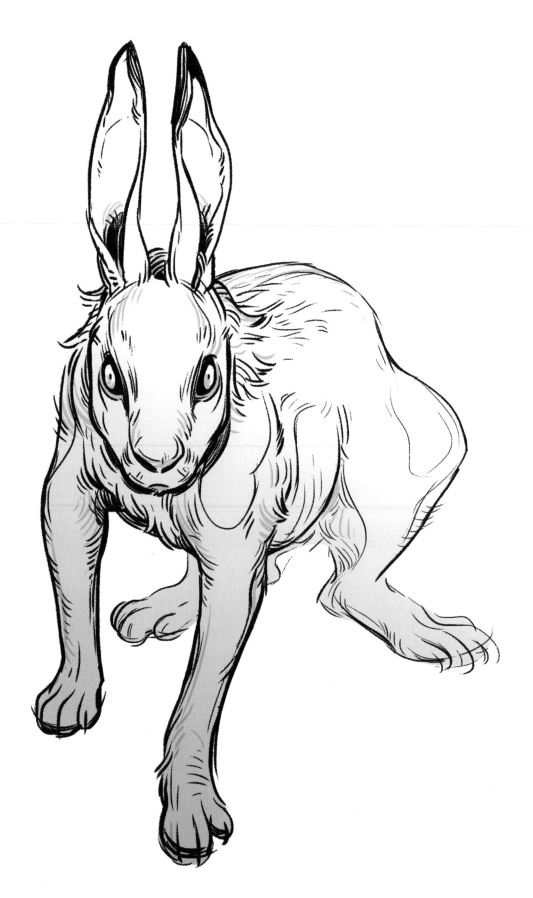

EDITOR'S LETTER

Thank you for picking up issue 09 of GRAPHITE magazine!

We hope you enjoy the exciting variety of artwork inside: from architecture and portraiture to robots and dragons, whether you're in the mood to pick up pencils, pens, or paints, there should be something for you.

In this issue, we interview Nicolás Uribe and Maja Wrońska, two incredibly talented painters; we explore inking and sketching techniques with Yorik van Havre, Alexander L. Landerman, and Mickael Balloul; and we learn how Katie Thierolf, Sara Tepes, and Marie-Alice Harel develop portraits and illustrations with pencils and more. We must also give our thanks to the brilliant artists featured in our gallery, and to Joanne Nam, who kindly created this issue's dreamy cover drawing.

As always, we appreciate your readership and support, and would love to hear your feedback and how you found us. We're excited to see GRAPHITE reach ten issues very soon!

Marisa Lewis
Editor

WHAT'S INSIDE

THE DREAM

Discover the ethereal artwork of Joanne Nam

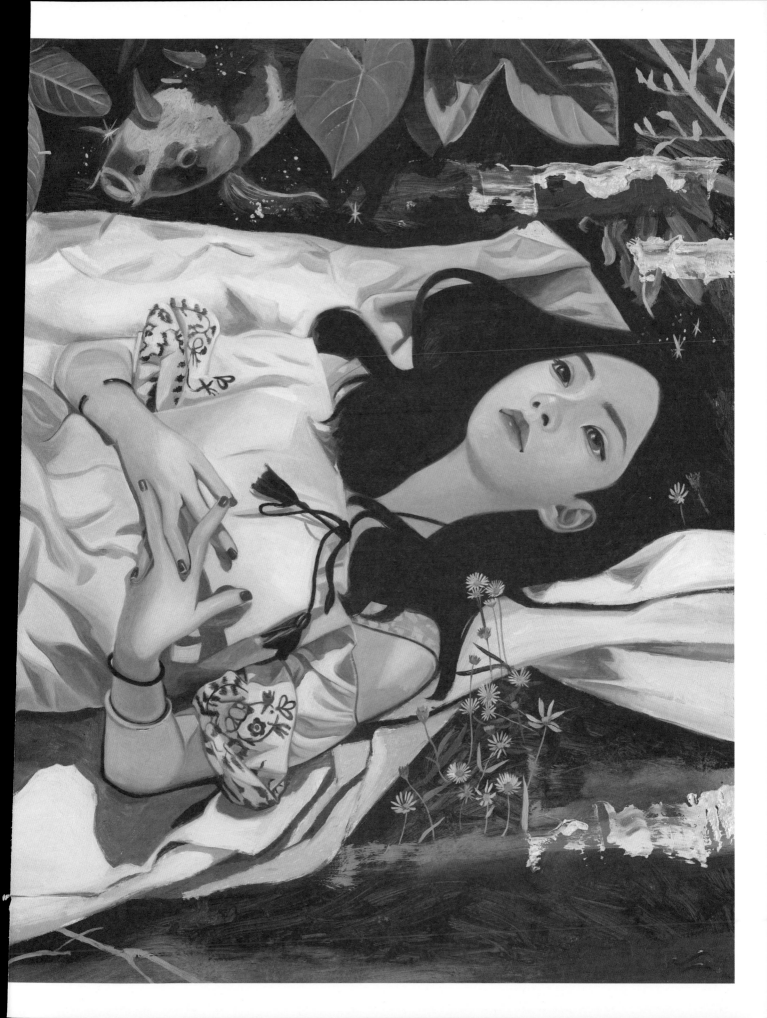

This issue's cover artist is Joanne Nam, a Los Angeles-based artist who paints dreamlike scenes in oils.

Q· What is a typical working day like for you?

A· I'm a morning painter, so after a bit of meditation I do my most creative work early. As the day wears on I switch to more business-oriented tasks like managing my social media, printing, and shipping. When necessary I call on my cat to restore my creative energy.

Q· What themes and motifs do you enjoy exploring in your art?

A· I enjoy mysterious atmospheres and I find a lot of inspiration in nature. I believe that is so because nature, while beautiful, has a very secretive and unknowable side. I enjoy placing the figure in these spaces because I feel I am creating a world as well as a persona to inhabit it. My work changes with my state of mind, which is itself informed by those I spend significant time with as well as the experience of the world around me.

Q· What advice would you give to aspiring artists?

A· I don't think there is an easy way to become the artist you want to be, or really any way to have overnight success. Patience, time, and hard work are my recommendation. If there's a secret, it's to enjoy the progress you make and to embrace the process of getting there.

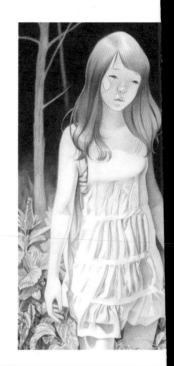

Far top left
Don't Know Why

Middle top left
Lost

Near top left
Garden of Eve

Far bottom left
Aurora Borealis

Near bottom left
The Dream

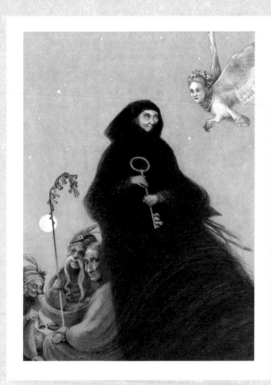

EXPLORING
SLAVIC
FOLKLORE

Illustrating in pencil with Marie-Alice Harel

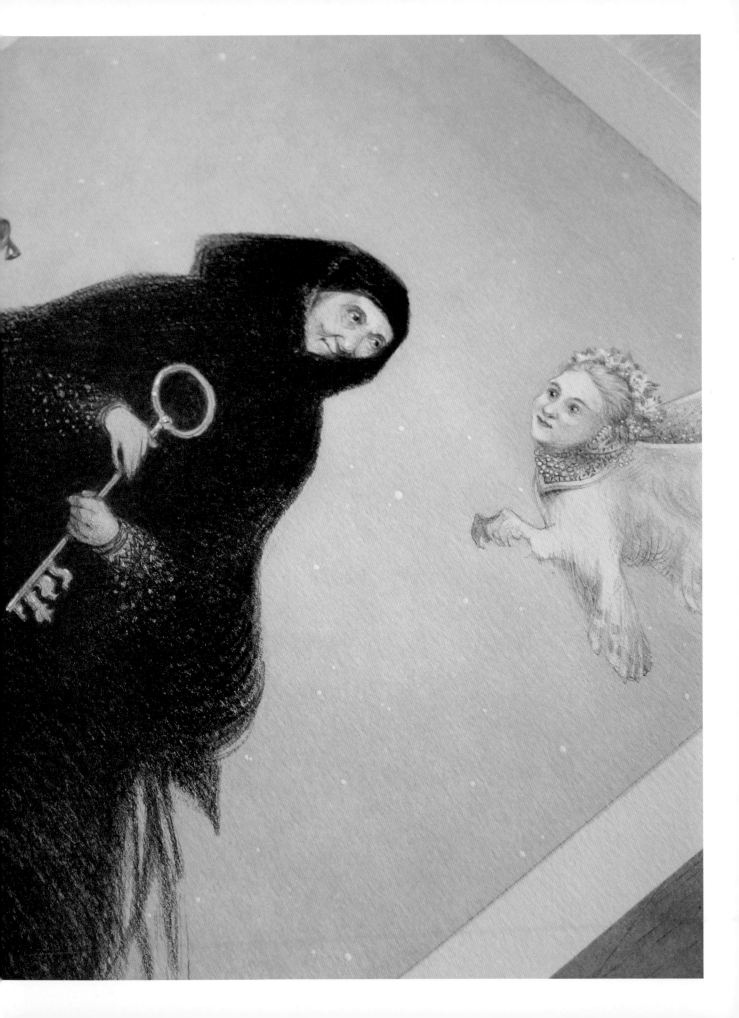

Join illustrator Marie-Alice Harel in creating a mysterious, atmospheric folklore-inspired image with simple pencils and ink wash.

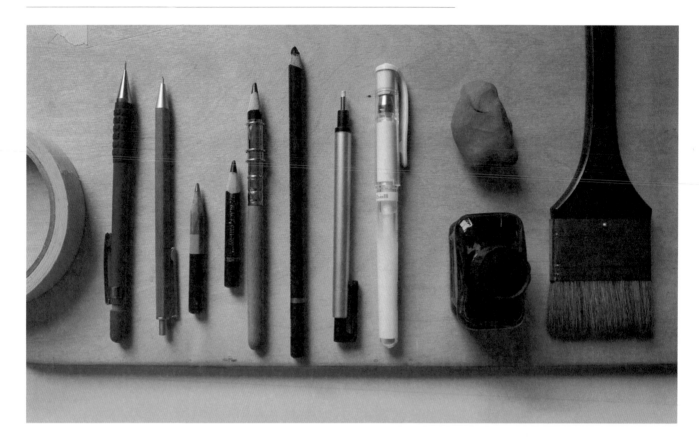

This project will be inspired by Slavic culture, using some folklore themes and imagery to build a picture that could suggest its own story. I will use pencils and ink wash to establish values and atmosphere.

Materials and approach

I try to make every personal piece an exploration: even if it builds on previous work, I want to leave room for experimentation, hoping to learn from the mistakes, surprises, and successes. After working mostly with watercolor last year, nowadays I want to play more with pencil and practice my use of values. So for this piece I will use two mechanical pencils (0.3 mm and 0.5 mm), a black Polychromos pencil for dark values, a charcoal pencil, a Tombow MONO Zero eraser (great for details and mark-making), and a white gel pen for highlights. I'll use a medium-weight drawing paper that will allow me to use an India ink wash to establish a middle tone. Masking tape and masking fluid will help when adding the ink wash.

Thumbnails

With Slavic culture in mind, I start with a very wide search in books and on the internet, looking for folklore, costumes, expressions, and gestures – anything that might catch my eye and spark my imagination. An image of an old woman holding keys makes me think about the idea of home, household protectors, and guardians. I also come across the Sirin, a sort of harpy from Russian mythology. Having recently read a book set in Russia in which one of the characters was a Domovoy (a household god or spirit attached to a family), a more precise idea grows in my mind, combining visual elements with my initial ideas. I start drawing some quick sketches to establish composition and values.

Above
Drawing tools: masking tape, pencils, erasers, a white gel pen, India ink, and a brush

Right
Thumbnail development with pencil and ink

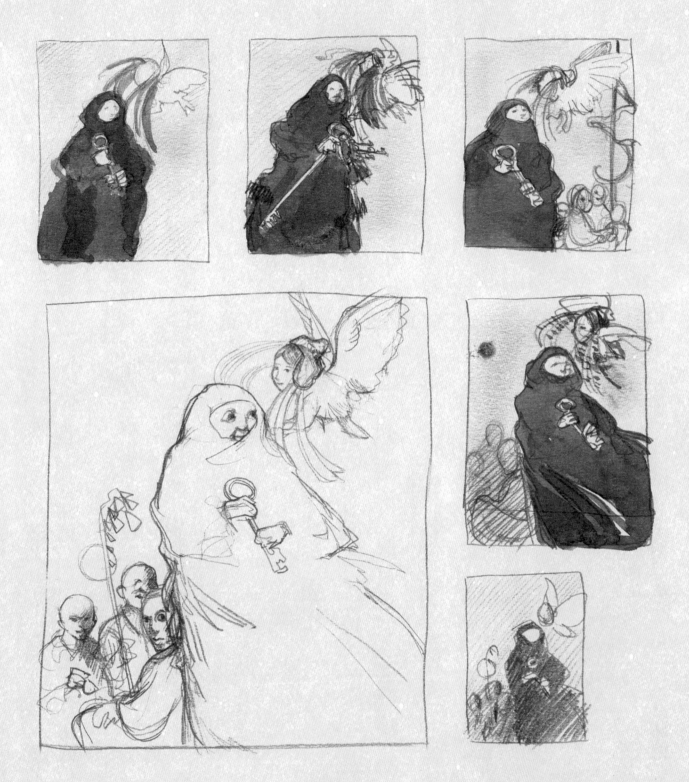

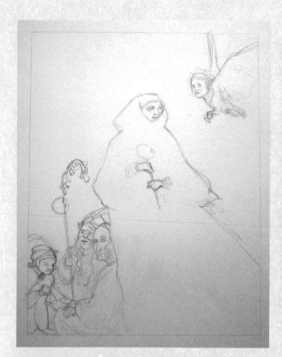

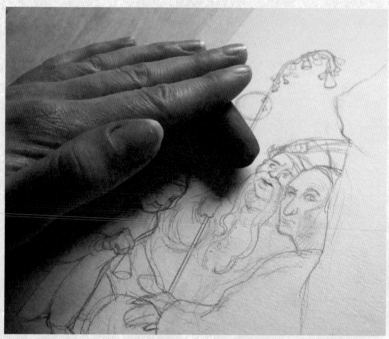

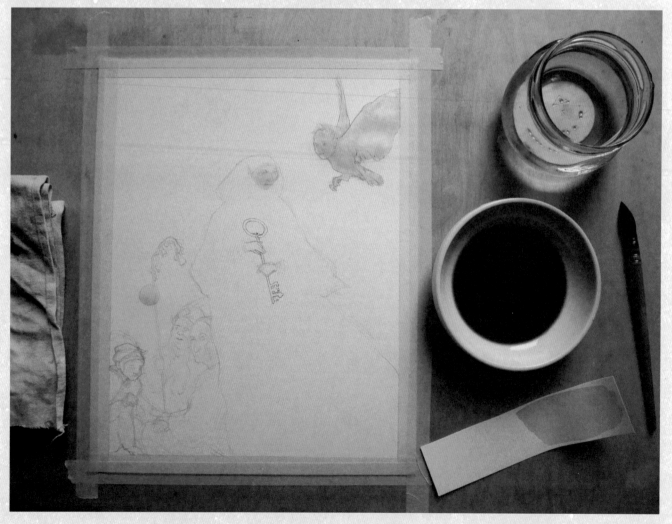

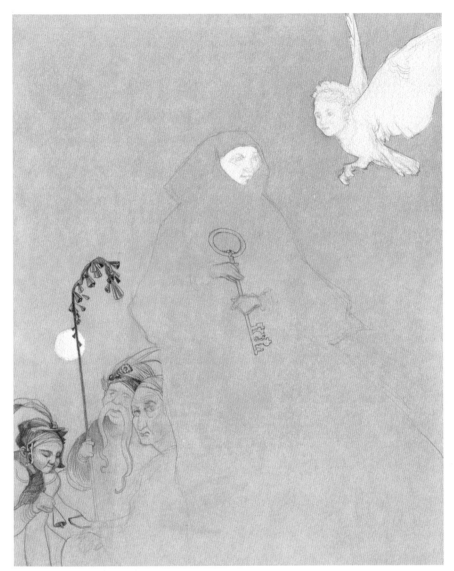

Initial sketch

Using my chosen thumbnail as a guide, I draw a loose sketch on the final sheet of paper, trying to keep it gestural, dynamic, with interesting shapes and rhythm. I would normally create the drawing separately and then transfer it using a lightbox (or window), but because the image will be quite dark and I want to keep exploring the characters as I draw them, I will jump directly into the final.

Fading the sketch

Now that I know where my characters and elements are placed, I partially erase the sketch in preparation for the ink wash. Pencil sinks into the paper after receiving water or water-based washes, becoming much harder to erase. For this reason I only keep faint lines to guide me. I also protect the border of the image with masking tape to keep it sharp and clean, and to hold the paper in place.

Masking and ink wash

To create atmosphere and unify the image, I want to apply a light gray wash of India ink with a large brush. First I use masking fluid to mask the Sirin, the old woman's face, and the moon, to retain the light value in these areas. When the masks are dried, I apply the ink wash. To speed up the process, I use a hair dryer to make sure that the paper is perfectly dry before drawing on top of the wash.

Far top left
Loose drawing based on the chosen thumbnail

Near top left
Erasing the sketch by rolling a kneaded eraser over the whole image

Bottom left and above
The ink is tested on a scrap of paper; the ink wash is applied over the masked sketch while the paper is taped to the drawing board

"The area where I want people to look first needs to have the highest contrast"

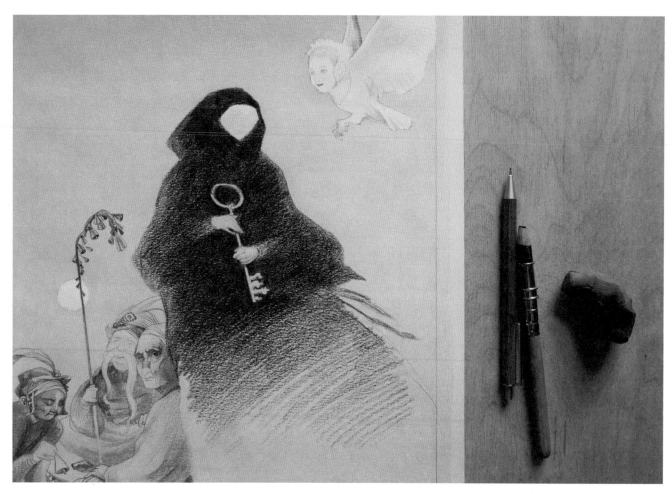

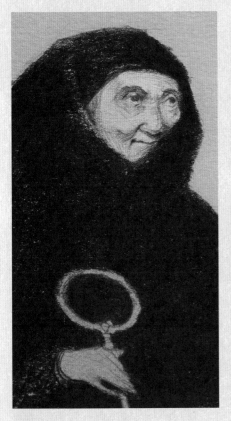

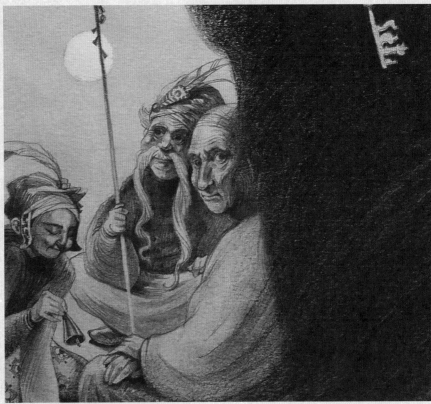

Building values with a visual hierarchy

Roughly starting from the left of the image (as I am right-handed), I begin to define the forms of the characters. I jump from one area to another to keep the values consistent without getting lost in the details too soon. I combine linework and hatching with uniform shading, using my fingers to blend the graphite. Clean, dry hands are essential for this, otherwise use a blender if you're afraid of irreversibly staining the paper.

When the pencil strokes are visible, I try to be mindful of their orientation relative to the rhythm of the overall image. Because I want the eyes of the viewer to travel along a diagonal arc, I choose this orientation when drawing the black robe of the old woman (with charcoal and black Polychromos). This decision suggests an abstract treatment of the lower part of the robe, blending its shape with the Domovoys on the lower left corner. This isn't something I planned in advance, as I keep making new decisions based on the

textures and shapes that I find interesting. Because the composition is quite static, having dynamic strokes in specific areas, not fully rendered, is something I like to do for balance and visual interest.

I make sure I follow the visual hierarchy defined in the value thumbnail. The area where I want people to look first needs to have the highest contrast (the lightest light next to darkest dark), the sharpest edges, and/or the most details. Here, the focal point is the old woman's face. The second area of interest, in my case the Domovoys, is very detailed with some sharp edges, but the contrast isn't as strong as the main focal point.

Expressions

Now that the main values are established, I move on to more detailed areas of the image, mainly the faces of the characters. This is where good reference is most useful to me. Using reference can be hard; it's easy to use it too much (copying, not interpreting) or not enough (being too generic when working

from imagination). Here I use reference to get the structure and shadows right, but I adapt this information to my needs. I want the expressions to be inviting and show the bonds between the characters, with this idea of home and household. One Domovoy stares at the viewer, enforcing this idea. I like the ambiguity here: either he has just turned in surprise and is about to invite you to join in, or he stares accusingly as if you were intruding in a private scene.

"The most detailed areas are where I want people to spend time looking"

Detailing

Now is the time to add all the details! It is easy to get carried away with details before the proper value structure is in place, which can lead to mistakes that can't be easily fixed, but the preliminary values are all in place here. I do not try to render the entire image the same way: the most detailed areas are where I want people to spend time looking. These specific zones are balanced by more unified areas where the eyes can rest and travel from one spot of interest to another. Here I add fine details around the Sirin's face, while her wing and body remain simple and clear.

Check for consistency

The image is almost finished. I step back and adjust the details and values for overall consistency. One way to do this is by using a mirror, as mistakes become obvious when you see the image reversed. You can also take a photo to see the image thumbnail-sized, or leave the image on the wall for a day or two if you have time. All of these can help you to gain a fresh perspective and before making the final adjustments.

Final details and highlights

Finally I can add spot highlights in opaque white to fully render and define specific areas; white gel pen or white gouache can be used for this. I especially focus on the eyes, the most important parts of each character. I add details to the sleeves of the old lady and sprinkle some stars in the background to create interest.

Above
Adding extra details
with the 0.3mm
mechanical pencil

Top right
Final details and
adjusting the values

Bottom right
Adding the final details
with a white gel pen or
gouache on a fine brush

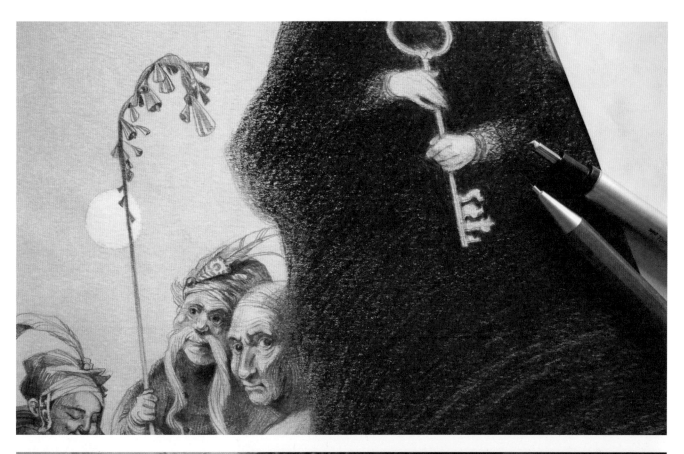

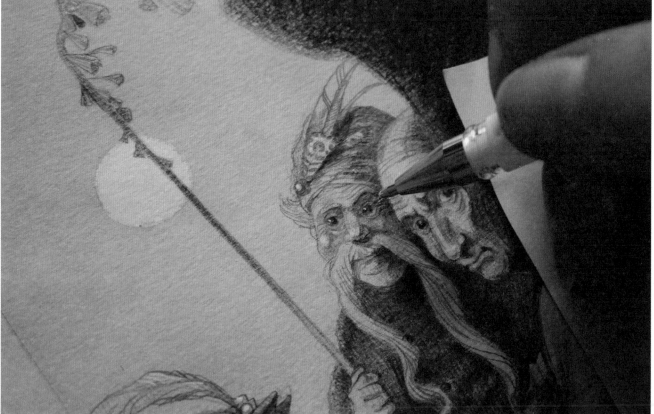

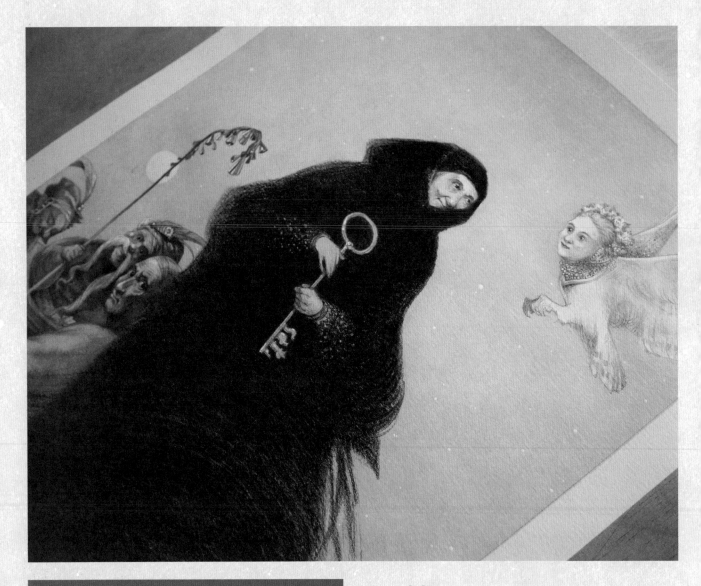

ARTIST'S TIPS

"Painting" with pencils

Pencils are not just for linework; they can have the same quality as paint brushes if you control your strokes (their definition, length, and orientation), your edges, and textures.

Don't show everything

Depending on your story and how the image will be used, you can control your subject, composition, and rendering to *suggest* rather than to *explain*. Sometimes the most important part of an image is what is absent or partially shown. It is essential to leave enough room for the viewer's own imagination.

Scan and clean

I can now remove the tape protecting the edges, heating it first with the hair dryer for easier removal. I scan the image in two parts, as the paper doesn't fit in my scanner, and use GIMP (an open source image-editing software) to make any final corrections. In this case, I remove some spots of dust, and adjust the perspective on the lower part of the key. Finally I desaturate the image and adjust its contrast, as much of it can get lost during the scanning process. Now I have my own original drawing and a high-resolution digital file ready to be printed or shared.

Above
The final drawing
ready to be scanned

Right
Final image
© Marie-Alice Harel

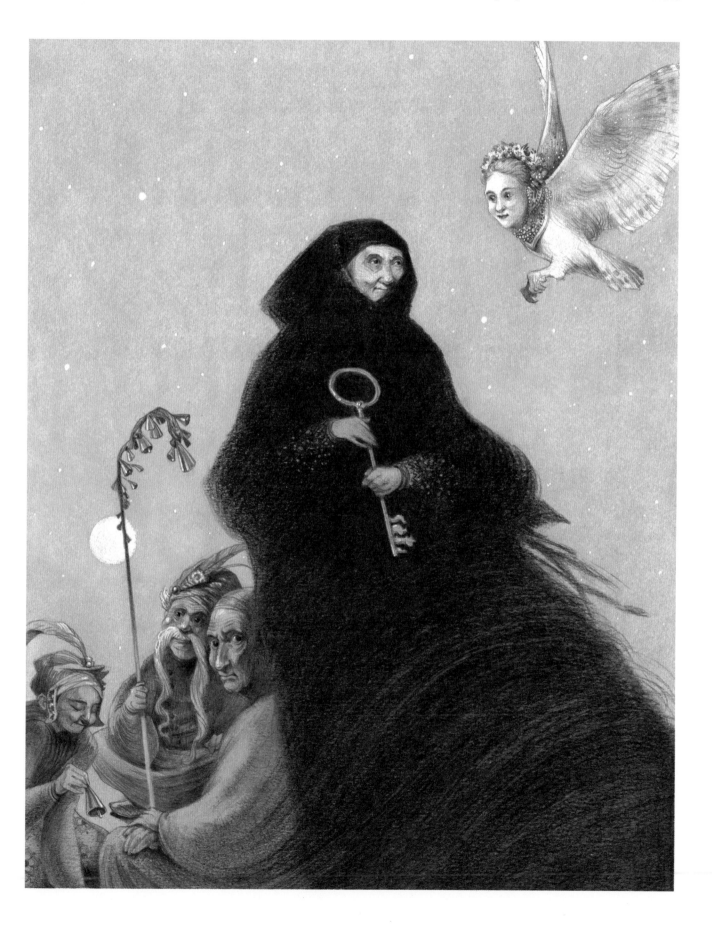

"A CONVERSATION WITH MYSELF"

An interview
with Nicolás Uribe

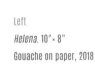

Left

Helena. 10" × 8"
Gouache on paper, 2018

Right

Sunflower. 28" × 28"
Oil on canvas, 2016

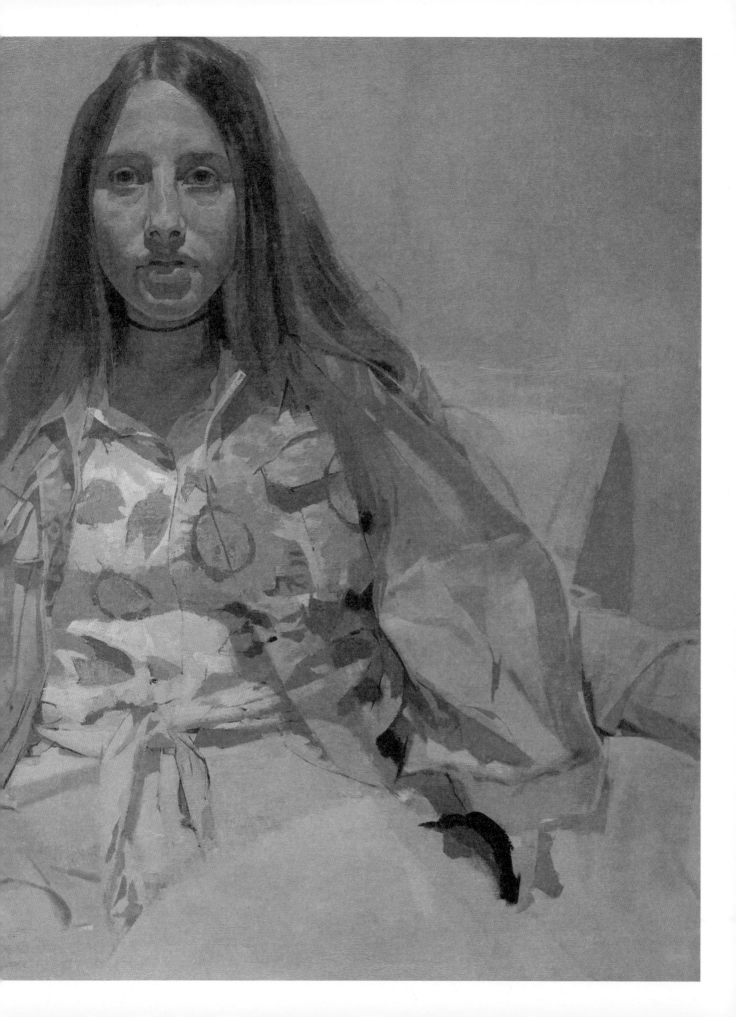

Nicolás Uribe is an artist with a passion for capturing human likenesses in a wide range of techniques. We learn more about his life and work here.

Q· Thank you for speaking to GRAPHITE, Nicolás! Could you please introduce yourself with a bit about what you do, your background, and where you're based?

A· I was born in Madison, Wisconsin, and spent the first year of my life there (with sadly no memories of dairy or cold winters). Then my family went back to Colombia and I was raised in Bogotá. My mother is an artist, her father was an artist, and my father was one of the most creative minds I will ever know. I received my BFA in Illustration from the School of Visual Arts in New York City, where I lived and worked as an illustrator for a while, before I decided to come back to Colombia to pursue painting full time. I have painted ever since, and currently teach

drawing and painting at a visual arts faculty, as well as happily traveling all over the world giving workshops.

Q· Who or what inspired you to pursue art? What inspires you today?

A· The answer has to be both of my parents. I was never judged, always encouraged. My interest at a very early age came from movies, TV shows, cartoons, comic books, fantasy illustrations, toys, and video games. I remember the subjects of my work solely being superheroes and monsters; specifically battles between the most irregular monsters I could imagine. Fast-forward to today, and while the monsters and superheroes have woefully disappeared as my subject matter,

the same sense of wonder and curiosity is injected into every single thing I draw and paint. I am fascinated by nature; in many cases I'm happy to try and learn from it and represent it faithfully, but at other times I try vehemently to be expressive, pushing and distorting its forms. I'm probably still a ten-year-old on the inside. I still want to look at art that just makes me say, "*Wow*, that's cool!"

Q· What tools and materials do you use the most, and why?

A· They are as varied as my intentions. I've always refused to look at artists as beings that are only good at one way of solving something. I believe we should be resourceful and open to as many different manners and techniques

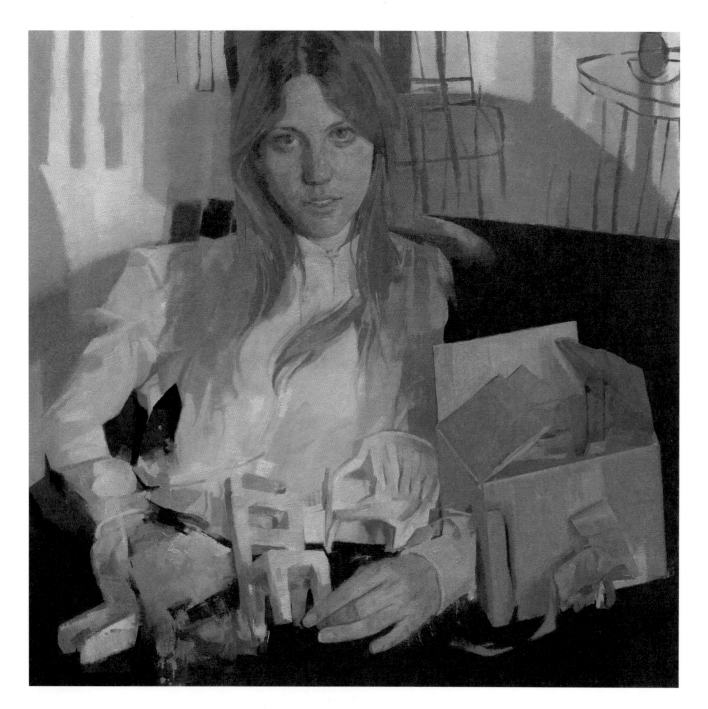

as are available to us. By doing this we will never grow accustomed to ourselves and our work habits. We will always explore the limits and the values and qualities that each of our tools has to offer. In that sense, I work with graphite pencils, vine and compressed charcoals, brush pens, calligraphy pens, gouache and oils, among many other things. I try not to differentiate between a drawing tool and a painting tool, because I believe that

drawing is an all-encompassing concept that is present in every single action an artist does. In my case, I am deeply aware of its relevance during the whole of my painting process.

Each image dictates its own rules and needs. I am always open to listening to those needs, and I try to choose the materials that will answer articulately to those intentions and execute the image to the best of my abilities.

Left
Luisa and *Diana*. Colored pencil on paper, 2018

Above
Chairs, box and Laura
28" × 28"
Oil on canvas, 2016

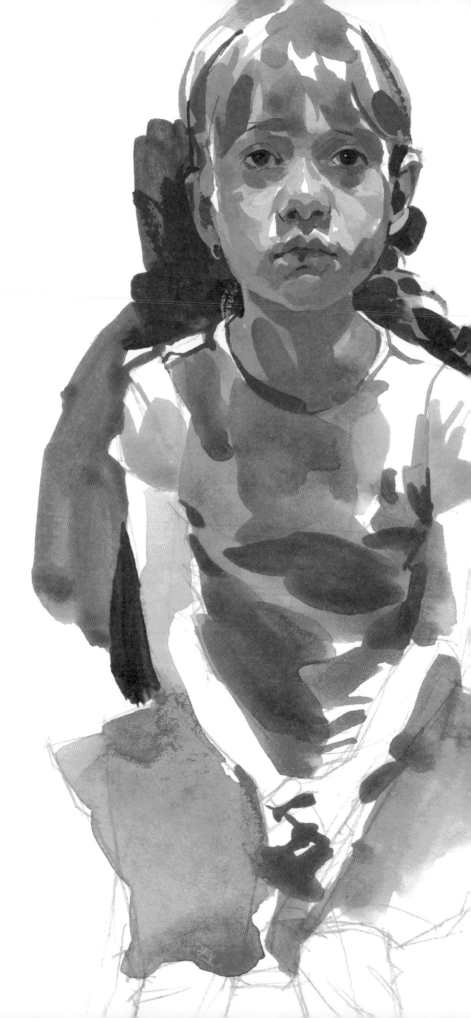

Q· Your figures and portraits have such a great sense of mood and naturalistic character. What do you enjoy the most about, or what draws you to, the subjects that you paint?

A· I feel that it is only through portraying people that I'm capable of having a conversation with myself. The paintings obviously speak first about the specific people I choose to represent; it is undeniable that I am drawn to exalting the characters of the people I interact with, but it is the act of painting that allows me to examine my sensibility and the manner in which I perceive. I explore my beliefs and my biases, I challenge the concepts I hold dear, all while depicting another human being.

This may seem hyperbolic and foreign to the simple act of translating observation into paint, but for me it is through portraiture that I give myself an opportunity to keenly listen. It helps me to learn more about my place in this world and my relationship to other human beings, and it is there where I teach myself tolerance and respect.

Q· How has figure drawing from life helped you as an artist?

A· Life drawing represents an experience that cannot be replaced by anything else. The connection we achieve and the nature of the judgments we make when we are directly in front of our subject cannot be replicated in any other scenario. It is by far the most important practice for an artist. It is also the most difficult one, because we are drawing *life*. Living nature, be it another human being, an animal, or sunlight, never stands still. Life breathes, changes constantly, and shifts, and by accepting this mutating quality, we become better at observing and valuing decision-making.

When drawing the model, we also gain consciousness of how varied and different we are as human beings. While all of our bodies may function with the same structure and

mechanics, each model is wonderfully unique and can express their character through particular shapes and gestures.

Q· Traditional paints can be a very challenging medium. What is your process for planning and creating an image?

A· It can be quite varied. Ideally, for more complex paintings, I'll make some quick, small sketches in graphite or ink, and try different compositions with varying shapes. My interest at this point is to explore how balanced I want my image to be, or how much tension I want to create.

After judging the possibilities that the sketches exhibit, I usually pick one and try to flesh out the bigger shapes and turn them into smaller, more precise shapes that answer more faithfully to whatever it is I want to represent. This is a tough moment because I want to keep the broader relationships of the bigger shapes, but I also want to acknowledge the specificity of the smaller ones. It's a fine, sensitive balancing act to try and have those two moments be present in the final image.

So essentially it's a lot of hard work before I even put a brushstroke down. Like I said, that is ideally what I want to happen, but to be honest, I often have a vague concept of what I want and I just improvise. I trust my instincts and know that the relationship I've forged with painting throughout the years will give me the tools to feel confident enough to find my way, even if I don't have everything planned out.

Q· What drew you into the field of teaching?

A· To this day I still remember and hold very dearly the idea of what my teachers meant to me when I was a student. They became such important figures in my life that it is hard for me to not mention them or at least think about them on a daily basis. Their impact in my life is simply invaluable. I often wondered if at some point in my life I could ever do the same for someone else. It would be awfully pretentious of me to suppose that I've had the same impact on my students that my teachers had on me, but the belief that I can be part of a young artist's career and play a significant role in their early development brings joy and pride to my life.

In the end, I just want to remind them of what it feels like to truly love and respect what we do, and hope that they can find joy and respect in their lives through art.

Left
Still. 10" × 8"
Gouache on paper, 2018

Above
Dani Nose and *Gaze*
10" × 8"
Oil on paper, 2017 and 2018

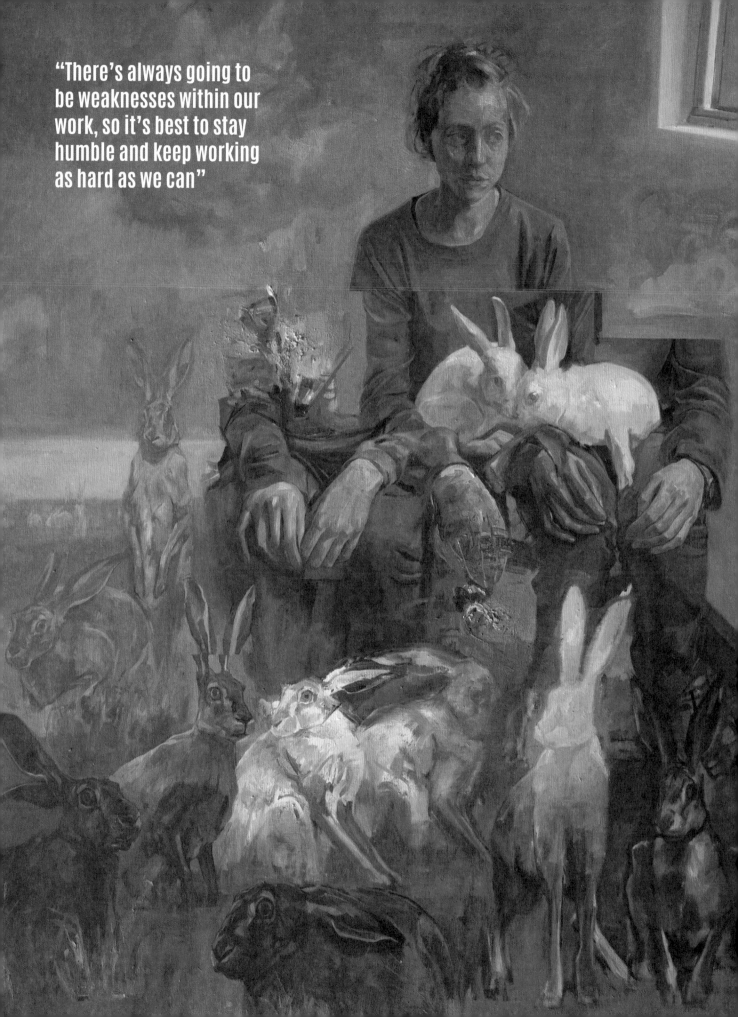

"There's always going to be weaknesses within our work, so it's best to stay humble and keep working as hard as we can"

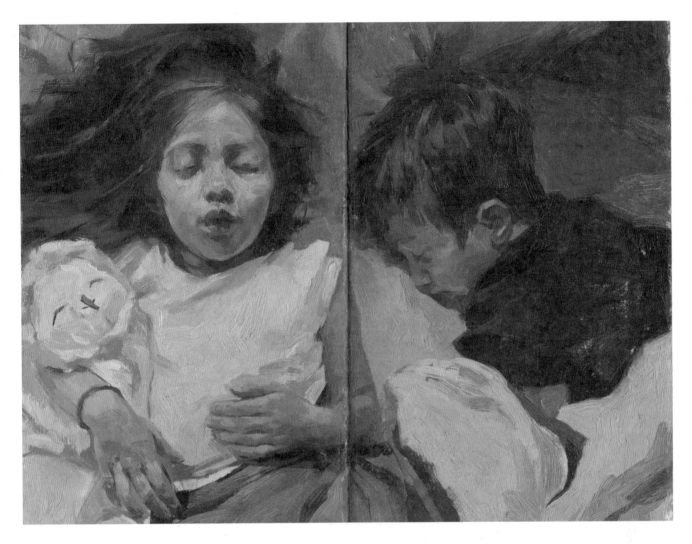

Q· What is one valuable lesson that you've learned in your career?

A· Reminding ourselves that *we're never as good as we think we are, and never as bad as we think we are.* There will hopefully be many times in our lives where things are going well, we're sitting on top of the world, and we feel invincible. We've finally made it. And there will be days – hopefully few of them, but they will happen – when we get rejected by something that we thought would have validated our work, when we struggle to make ends meet, and when we feel our talent and creativity are superficial. During both these times we have to remain calm.

When we are at our highest high, the truth is there's always going to be someone better than us; there's always going to be weaknesses within our work, so it's best to stay humble and keep working as hard as we can. At our lowest low, we should remember that if our work is honest in its intentions, and we thoroughly enjoy what we do, we will always have one of the most powerful allies and closest company for the rest of our lives in our drawing and painting. Always be humble and always work hard.

Q· What do you like to do in your spare time?

A· I spend as much time as I can with Samu and Fer, my son and daughter. That's probably my number one priority. But in my own time I love to watch soccer (I did play soccer, but was never good), play video games (my favorites include *Inside*, *Cuphead*, *God of War,* and the *Dark Souls* series), and watch movies (anything by Wes Anderson and Yorgos Lanthimos). I also hang out with my girlfriend Dani, who is an awesome artist. And I'm trying to eat less pizza.

Left
Hares
48" × 36"
Oil on canvas, 2015

Above
Fer-Samu
8" × 10"
Oil on paper, 2018

SKETCHING
SÃO PAULO

Urban sketching with Yorik van Havre

Join architect and urban sketcher Yorik van Havre as he uses ink and watercolor to document his favorite sites in São Paulo, Brazil.

I am an architect from Belgium but have been living in São Paulo for the past ten years. I work as an architect by day and as a programmer by night (but not every night – don't worry). I had not drawn much since I was an architecture student, but I heard about urban sketching a couple of years ago, and last year I attended a meeting of the city's local Urban Sketchers group. It was love at first sight. I now go out drawing with the whole group, some friends, or alone, as much as I can.

São Paulo is a fantastic place to draw. It does not have many tourist attractions and monuments, but those who like cities usually love it. It has a very strong *bairro* ("neighborhood") culture, and is full of people, contrasts, and things to see, hear, smell, and eat. And, amid the chaos of a rapidly-growing city without many rules, the wonderful Brazilian modernist architecture is everywhere to be found.

There is an Urban Sketchers group in almost every big city in the world – just search the internet for "urban sketchers" and the name of your city to find your local group. In this article I will show you some of the useful sketching tricks and techniques that I have discovered so far.

Centro

The *Centro* (downtown area) of São Paulo is a very lively and busy area, largely pedestrian, occupied mostly by offices. The vast majority of shops underneath are restaurants and luncheonettes. It's easy and cheap to order large portions of good, healthy food that someone prepares in front of you. At lunchtime, everybody is in the street, discussing where to eat.

The great thing about urban sketching is trying to capture this chaotic mix of things – some of which are not "drawable" – that make a great city come to life. These places

full of people and details are exactly what I like. When drawing whatever there is in front of you, be it beautiful or ugly, you always end up capturing something of that atmosphere. There is no need for your drawing to be precise, or beautiful, or realistic. It's more about drawing what happens.

I always start by choosing a good frame – looking at the scene through a phone camera helps a lot – and then setting up the perspective for my drawing. This is a very important step for me, and I do not go any further if it doesn't feel right. I identify perspective lines, find the "vanishing point" where they all lead, and put that point down on the paper (or make a mental note of where it would be, if it falls outside the page).

Next I draw the people, because they are usually in front of the buildings, before filling in the rest of the scene and adding some color with watercolors.

"I now go out drawing with the whole group, some friends, or alone, as much as I can"

ARTIST'S TIP

Obey perspective

The only real rule you need to watch at all times is that "all parallel lines recede towards the same point." As your brain tries instinctively to rectify this and make everything square, because it "knows" that buildings are square, you must constantly fight it and remember to not follow your instincts. Make sure you check, line after line, the point towards which the scene's perspective should be going.

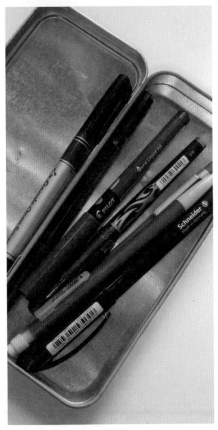

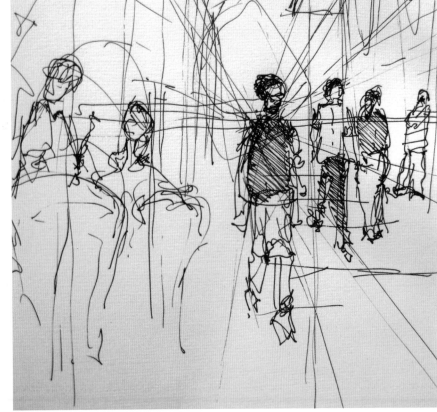

"People are the hardest to draw, but also the most fun"

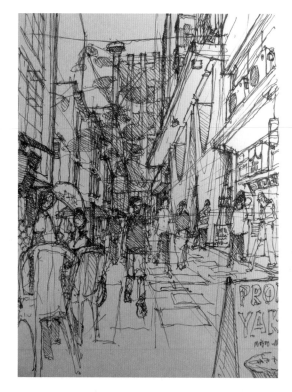

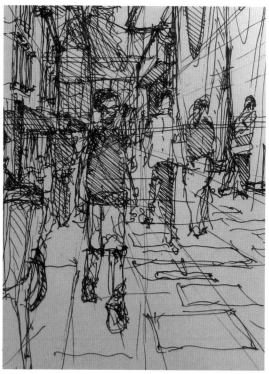

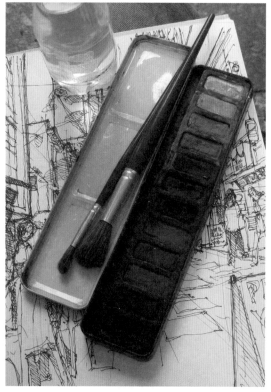

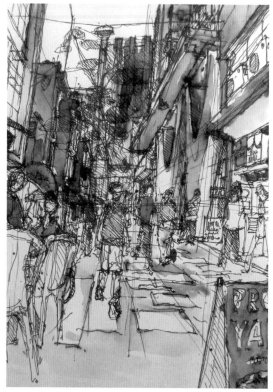

Top left
This is the stage when I start to think, "If I were smart, I would stop now!"

Far bottom left
The inexpensive watercolor set I use for sketching on the go

Near bottom left
The key is not to put too much color on the page. I only paint well-defined areas, putting some drops of color around, while keeping lots of white areas

Right
Final image
© Yorik van Havre

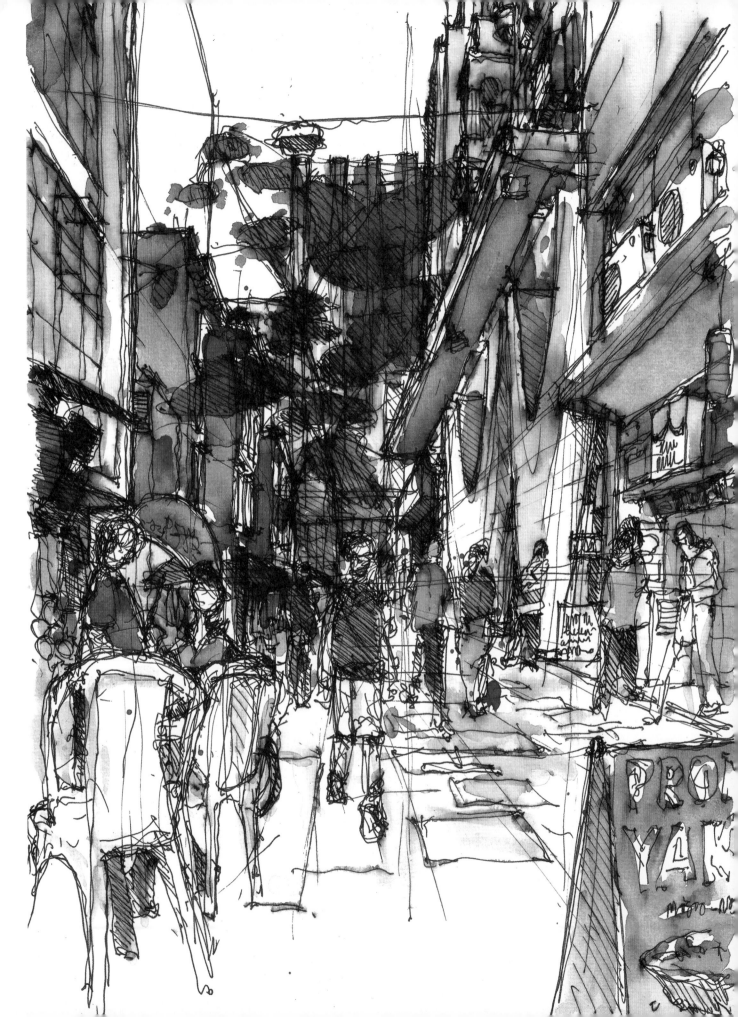

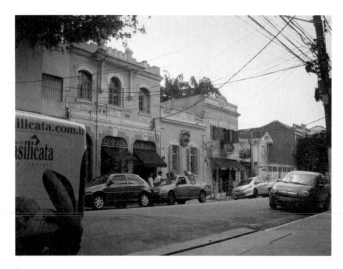

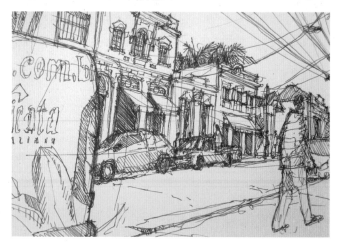

ARTIST'S TIP

Copy your inspirations

I have learned all my drawing techniques through copying someone else I admired. Find urban sketchers you like on social networks and watch their drawings closely. Try to understand what it is they do that you really like, and try to imitate that quality. You will make huge progress.

Bela Vista

Bela Vista ("nice view") is one of São Paulo's oldest Italian immigrant neighborhoods, of which there are several. Although located next to the city centre, it is an anachronistic, peaceful oasis in the middle of the chaotic urban sprawl. Here, time passes at a different speed. I drew this scene on a cloudy afternoon, shortly before the end-of-day summer rain which occurs daily. This made the whole scene feel even more still. The only sound I could hear was the chatting of the people busy unloading a vehicle in front of me.

It is common for me to make a few mistakes while drawing the main perspective lines. After a little time, your drawing will begin to diverge slightly from the reality because of things you have placed differently. At that point, you begin to obey the drawing rather than reality, as the perspective of the drawing must be respected, no matter what.

I recently discovered this technique for painting skies: just paint a little bit of blue, between the clouds, "sticking" to the buildings as if it was smoke.

Watercolor is still a relatively new medium for me; I had always considered it "boring," but then I discovered the work of urban sketchers around the world, and my opinion changed radically. Now I find it fascinating how watercolor brings a drawing to life.

Far top left

A lazy afternoon in Bela Vista. Locals have a little chat while unloading goods

Near top left

In my initial sketch, I drew the van at the front left too far to the right. You can see where I redrew and fixed it before going further

Far bottom left

I started by drawing the cars first, as I feared they would move soon. In fact, they did!

Near bottom left

Don't worry about "wrong" lines. They end up blending into the drawing and almost vanish

Top right

The pen I used here bleeds a lot. Always carry a tissue with you to remove some of the pools of ink or watercolor

Bottom right

Final image
© Yorik van Havre

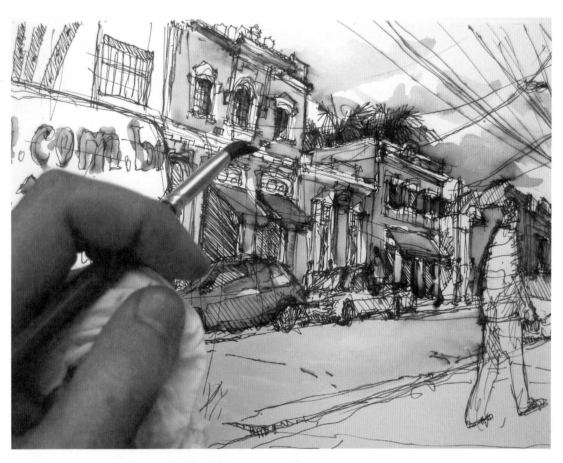

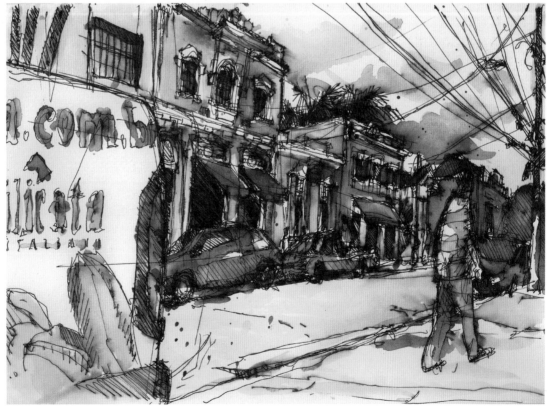

ARTIST'S TIPS

Don't be afraid of "wrong" lines

When drawing, we (or at least I) draw more "wrong" lines than "right" ones. This is not a bad thing, as it can make your drawing richer, especially in a permanent medium such as ink. Draw the line again, until you have one that is right, then mark it more strongly so that you remember which one is correct. If you don't like having so many lines in your drawing, you might prefer using a pencil, with which you can make the provisional lines very light until you find the right one.

Save money on materials

All the materials I use are quite cheap. Any paper will do. Even common printer paper is very good for pen work, but use something at least 180 gsm in weight if you are going to add watercolor. My watercolor set cost fifteen dollars. My black pens are common ones that can be found in any office supplies store, where they'll usually let you test them; I have both cheap and expensive pens, but to be honest I rarely see much difference.

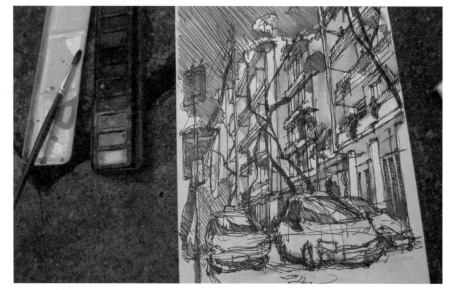

Higienópolis

Higienópolis ("Hygienic city") is a strange neighborhood born from some enthusiastic modernist minds in the middle of the last century, and likely from some juicy real estate manipulations as well! Imagine a neighborhood made completely of concrete buildings with large terraces and pilotis, and streets covered with jungle-like vegetation. Whoever said São Paulo was not green?

This sketch was made on a warm afternoon, but the temperature below the trees was just perfect. I think of this area as a big natural climate regulation system; Brazil is one of the rare places in the world where those modernist theories came to such a fruitful result. I deliberately chose an angle with the sun in front of me, to give a dark look to the canopies of the trees, with spots of light coming through.

The challenges of this sketch were to capture the sense of the huge, vertical dimension of that space under the trees, and then to render the contrast between the dark and lit areas.

I used one technique that I like a lot: painting everything with only one color at first, which then served as a guide for the next colors. A useful trick is not to think in terms of colors, but in terms of light or dark. Forget which color it is: just put more color where the scene is darker, and do the same with the subsequent colors that you add.

Another trick I like is to sprinkle a few final drops of very saturated color with the brush. This makes light pop out and adds interest to the sketch.

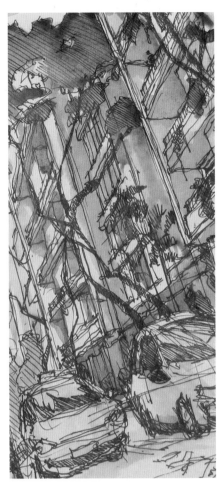

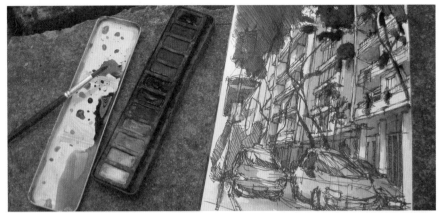

Far top left: Lush vegetation, modernist or proto-modernist concrete buildings, flowers, birds singing: This is Higienópolis

Near top left: It is hard to know what to draw at first. I decide to start with the building on the right, as it seems important to get it right

Bottom left: A technique I learned recently: use only one color, in a quick, light layer first, then add stronger touches in dark areas.

Above: Playing with yellow and blue is always interesting. The layers of color begin to bring out the contrasts in the scene

Top right: I often need to bring in areas of black ink or black watercolor at some point in a sketch, but I always try to keep that for the last moment

Bottom right: Final image © Yorik van Havre

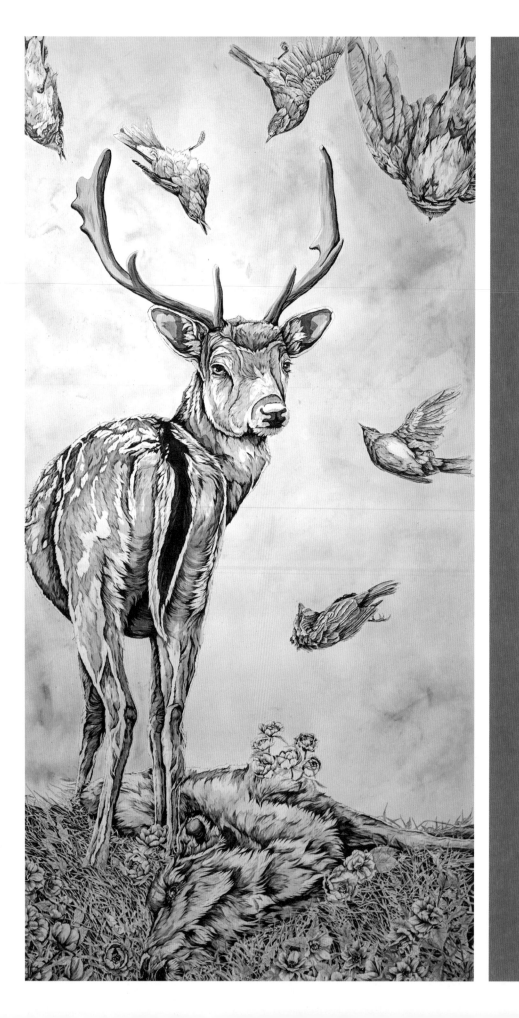

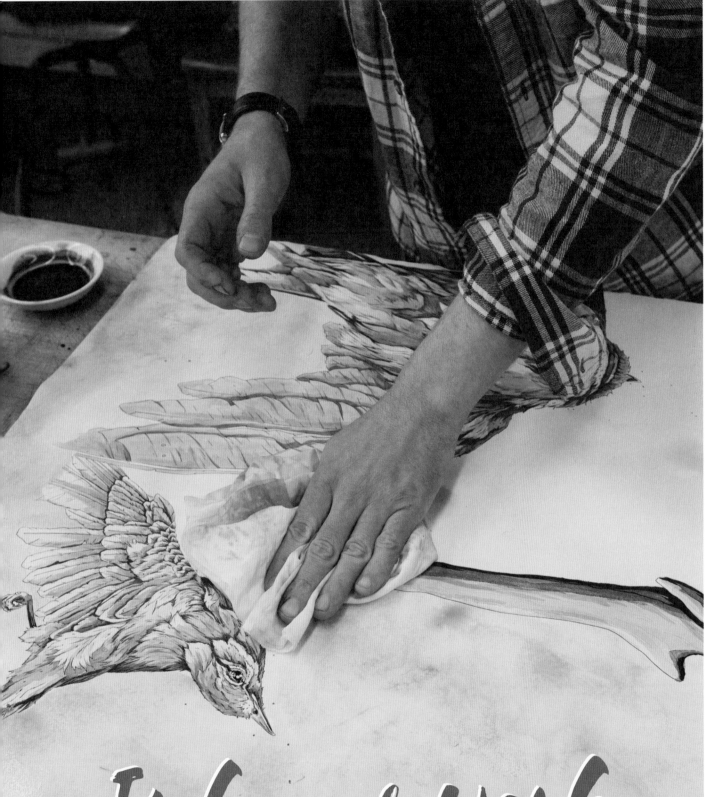

Ink and Wash

Approaches to large-scale drawing with Alexander L. Landerman

In this article, Alexander L. Landerman shares his process and advice for developing a large-scale illustration with pencil and ink.

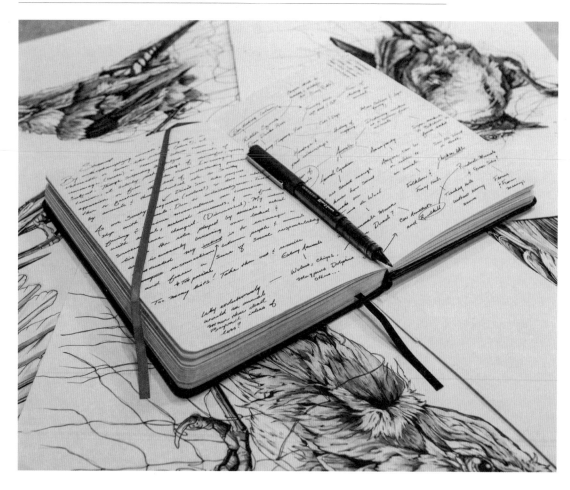

Left
A catch-all notebook carried at all times, loaded with everything from drawing ideas to grocery lists

Top right
Apartment studio/ Landerman HQ

Bottom right
The drawing and inking tools used for this project include felt-tip and fineliner pens, dip pens, and a range of brushes

If you are reading this, the chances are that you are already familiar with sketchbook drawing. In order to show you something new, I will work on this project at a large scale on roll paper, with pen and ink, and talk about some of the problem-solving involved in the process.

Research

When beginning a project, I always build off the ideas and drawings that came before it. I have a notebook full of bric-a-brac and new ideas; I find it's helpful to do a little writing and word-mapping to remind myself of what I want to say, and to organize my thoughts. Sometimes I go as far as writing an artist statement by hand to help me think about each word in relation to the project.

Workspace

Most of the work on this piece will be done in my home studio, which is small, so don't let a small space deter you from working large. A drafting table can be an amazing asset but is not necessary. A friend found my table for me on the curb for $20; tables are always popping up for sale online, and with some effort and desperation they can be crammed into any compact car. Having a designated workspace and the ability to tilt a table is delightful. I keep my space clean to avoid accidents and distractions.

Mark-making tools

There's no good or bad and right or wrong in art, but we have all used some poor quality tools in the past, and they can make working awful. For this project, I will use some of the tools I have come to love and use regularly. I use both a dip pen and a felt-tip pen. Felt-tip pens don't catch on the paper and splatter, but the ink is never as rich as that of a dip pen. For the best results, I blend the two.

When it comes to choosing an ink, I advise buying waterproof ink, as it will allow you to layer watered-down ink without any bleeding. As for brushes, a good brush will last for years, so buy good quality brushes and take care of them. I still use my dad's brushes from the 1970s, and someday I will pass them on to my starving artist children!

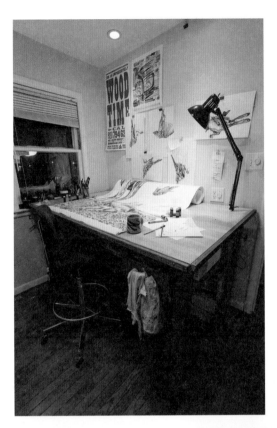

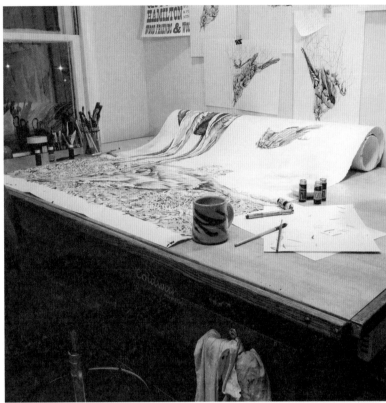

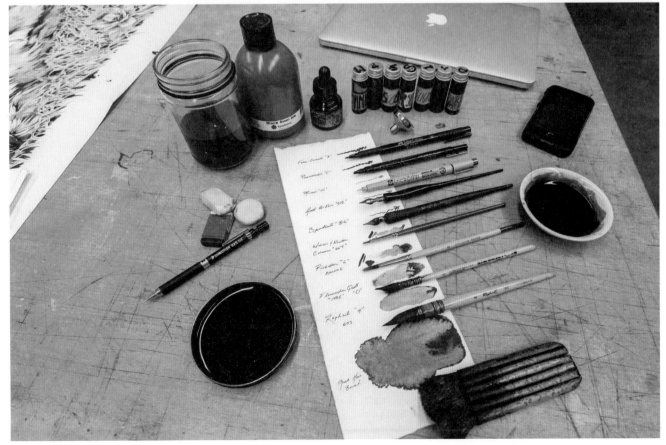

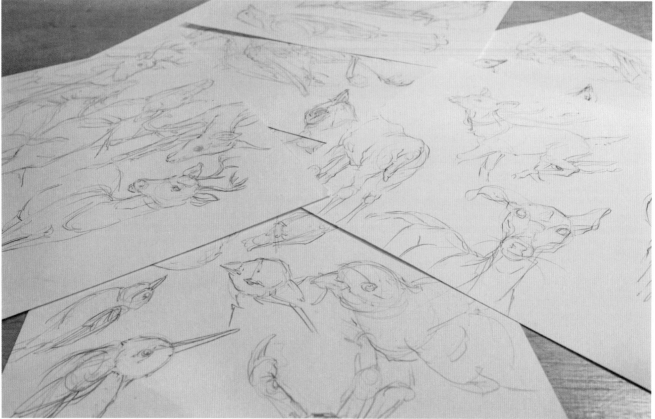

Paper

Choosing paper is difficult and I have made many bad decisions in the past; save some cash by learning from my mistakes. For this project, I will use a 106.7 cm x 9.14 m roll of Rives BFK 300 gsm cotton printmaking paper. This paper is tough and can stand up to brutal erasing, but also has a beautiful tooth and takes ink well. This is not the only paper, or even the best paper, but I love it. It works well for both wet and dry media, and the price is affordable while still being of archival quality.

Sketching

Do yourself a favor and sketch first. Sometimes I get excited about a project, start the drawing immediately, and inevitably finish the piece wondering at my composition choices. I start this drawing by roughing my ideas out on cheap loose-leaf paper before moving on to thumbnail sketches. These sketches are fast, simple, and intended to be recycled at the end of the project, so I don't spend a lot of time refining them.

Layouts

This is where I start thinking about overall page layouts. They are a little more developed than the previous sketches, and allow me to focus on the narrative qualities of the piece, thinking about what belongs where. When I am not working on commissions, I tend to make animal-based artwork that often anthropomorphizes animals, placing them in moments of tension. This drawing will continue with those concepts, showing a deer surrounded by falling birds, with another deer lying at its feet, but you can apply this process to the subject of your choice.

Far top left
The roll of Rives BFK printmaking paper used for this project

Far bottom left
Early sketches and studies of deer and birds

Near top left
Moving from thumbnail studies into simple layout ideas for the drawing

ARTIST'S TIP

Take a break

I draw as much as possible. When I'm at a residency, I put in a minimum of twelve hours a day and love it. That being said, it is important to take breaks. I try to make myself go for runs (with my dog), go for walks (with my dog), and cook (for my dog). These short breaks make a great difference for my patience and focus, and always lead to better work. So, make sure you take breaks (preferably with a dog).

Tracing paper

When working with a drawing of this size, I have two approaches. Sometimes I will sketch, make thumbnails, and proceed straight to paper, but I have found that thumbnails do not always translate well to large drawings. My other and more effective method is laying the illustration out on tracing paper or newsprint that I can then move around until I find a pleasing composition. This, in the long run, has saved me a lot of time and heartache. Here I have roughly blocked out the scene, with the living deer turned towards the viewer and the birds falling around it.

Under-drawing

Now I sketch out my chosen composition on the roll of Rives BFK paper. I always start in pencil and sketch loosely, using basic shapes. Depending on the project, I sometimes leave my sketch lines intact, but for this piece, I remove them entirely as I work. I use my pencil to make a more detailed sketch, then add a soft, loose ink wash to give more definition to the subject matter. This soft ink wash is the point of no return for the drawing, so I make sure that I am confident in my layout first.

Near right
The cheapest tracing
paper money can buy

Far right
Fast and loose drawing
using the whole arm,
and adding a soft ink
wash with a brush

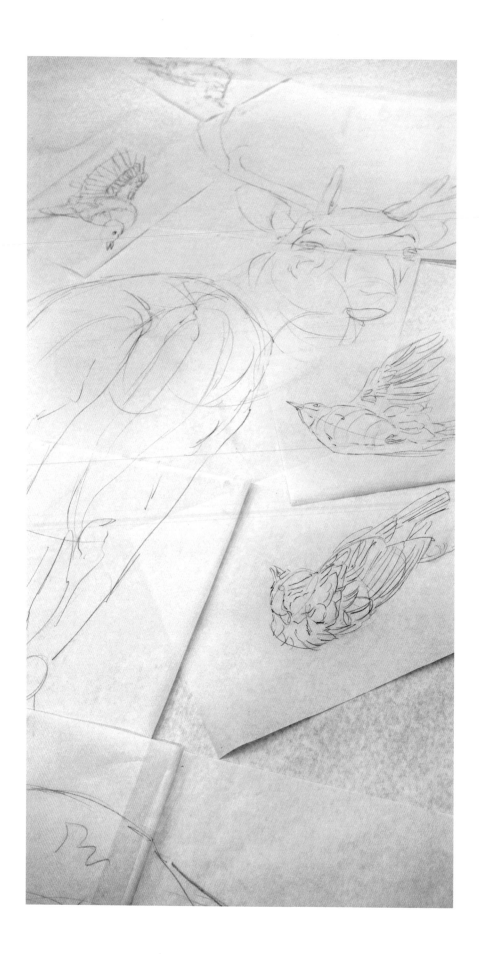

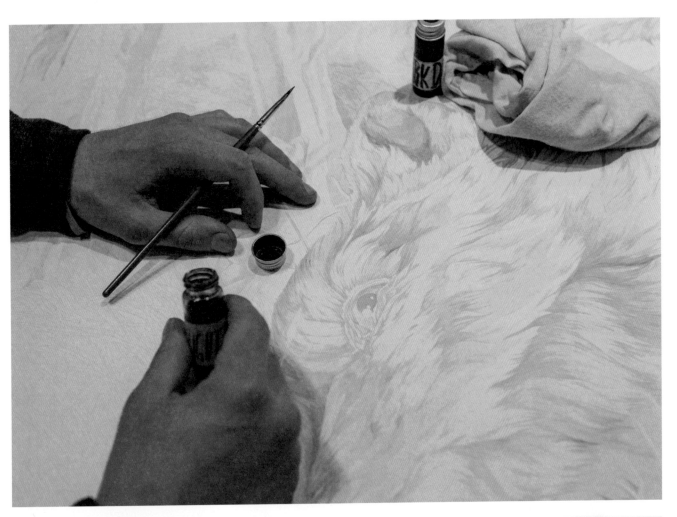

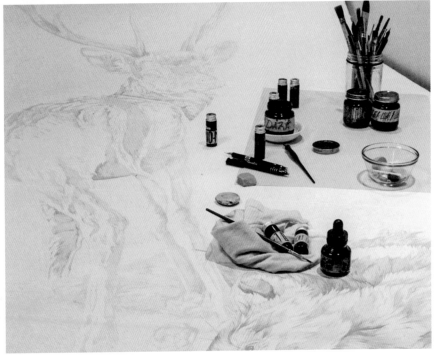

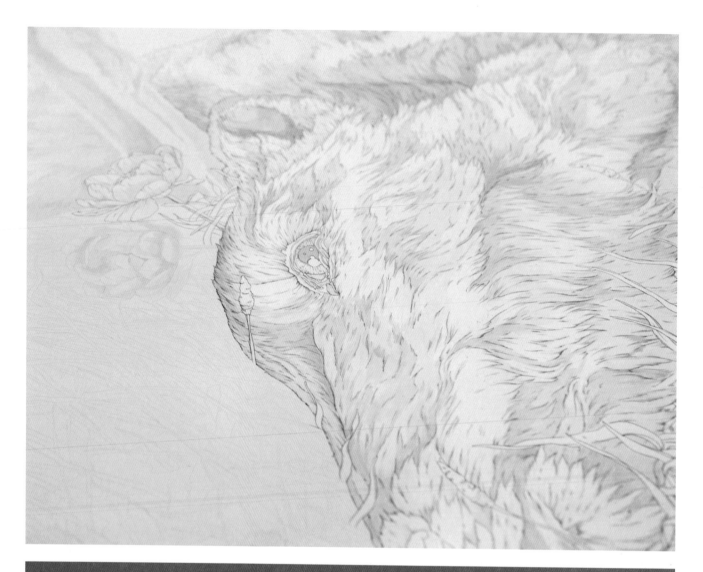

ARTIST'S TIP

Little jars

I used to store my ink washes in baby food jars, but found the lids were not tight enough to travel with. I have since switched to keeping ink in these small travel-sized jars which don't leak and fit easily in my hand while I work. I work with jars of pure black, dark, medium, and light ink wash, and keep several larger jars around the studio for when I am adding background washes or rinsing brushes.

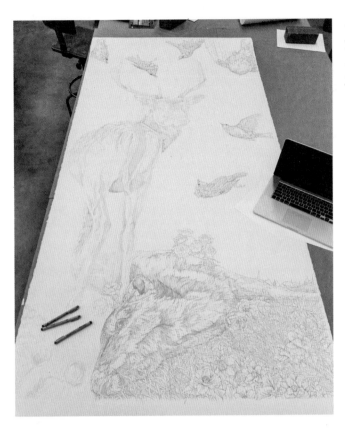

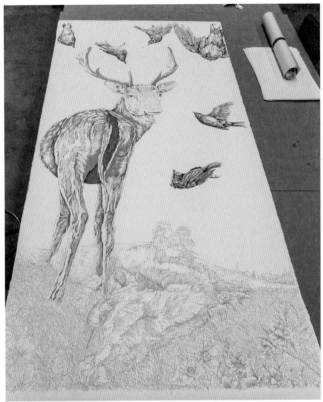

Inking process

After the ink wash is completely dry (a hairdryer is always helpful), I start inking over the pencil drawing and ink wash with a felt tip pen. I use a Micron 01 pen because there is no risk of the nib catching and splattering, and it does not need to be dipped. I think of this stage as the "coloring book" stage, where I am giving myself hard lines to follow and build up throughout the drawing.

Developing the drawing

Once the outlining is finished, I slowly add depth to the piece by working from dark to light, building up layers of watered-down ink with a small brush.

I compare this stage of the drawing to watching a photo develop. I always enjoyed watching photographs come to life in the darkroom and this process is very similar.

Left
Inking over the pencil
drawing with Micron pens

Above
Building up ink shading
within the lines
drawn previously

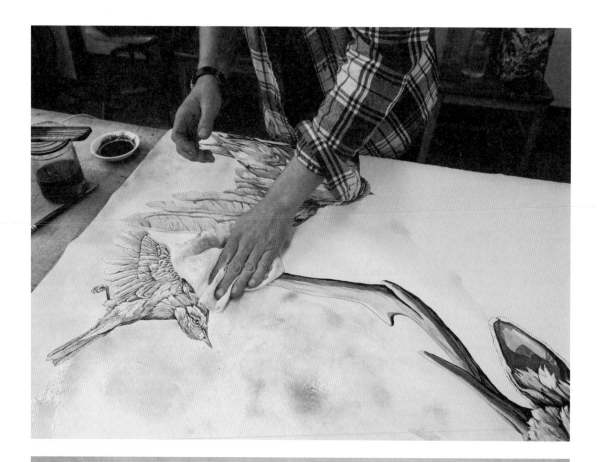

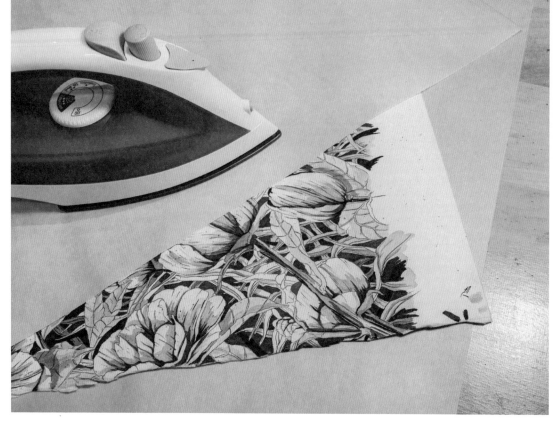

Near top right
Using a large goat-
hair brush to add
soft background
layers and drying the
results with a rag

Near bottom right
Smoothing out the
wrinkles using an iron

Far right
Final image © Alexander
Landerman

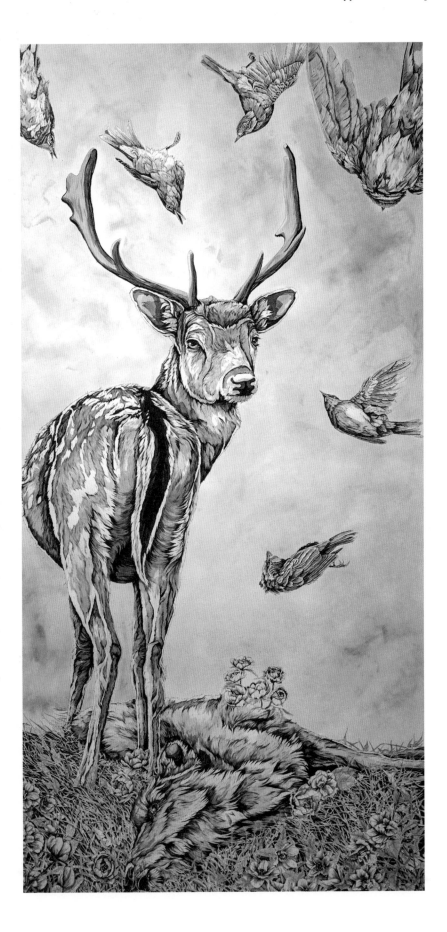

"Ironing a drawing is a great way to flatten it"

Background ink wash

To develop the background, I add water to my image using a large mop brush, then slowly drop ink onto it with a smaller brush. I use very diluted ink and take my time with this process, blotting out the ink and water with a dry rag as I go. This dry rag adds texture to the background and gives it a great deal of character.

Flattening

Ironing a drawing is a great way to flatten it once it is complete. As a fellow artist, I am sure you'll understand when I say nothing in my home is safe: every mug has had watercolor in it, my slow-cooker is used to dye paper, and my iron is used to melt wax. So, first be safe and clean your iron off. Next, lay sheets of newsprint under and on top of the paper to protect it from smudges. Start ironing over the newsprint with your iron at a low temperature, and increase it gradually if needed. If you are unsure, there are many useful YouTube videos that will help you to familiarize yourself with the process.

Finishing and documenting

Unlike charcoal and graphite, ink does not need to be sealed with fixative or varnish. When you're done, you're done. For documenting the final image, I use some mid-grade, continuous, white-balanced lights, and a Canon T5i Rebel camera. If you do not own lights and a camera, wait for a sunny day, tape your piece to an exterior wall in the sun, and borrow a camera from whoever will lend you one! I have spent a lot of time begging to borrow high-quality cameras, and it's worth it to have good images for submitting to shows and for your website.

Lowell
© L Filipe dos Santos
Colored pencils and oil
pastels on cardboard

THE
GALLERY

Featured artists:

L Filipe dos Santos

Oriel Barnard

Julia Griffin

Sarah Mason

Laura Hines

GWAJA

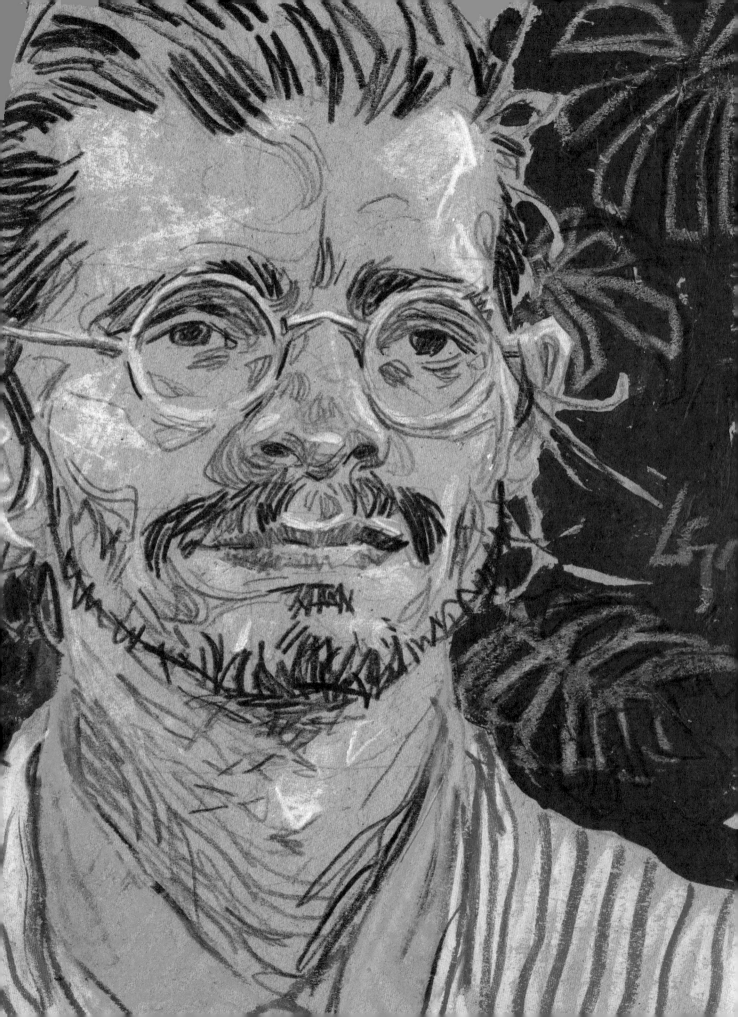

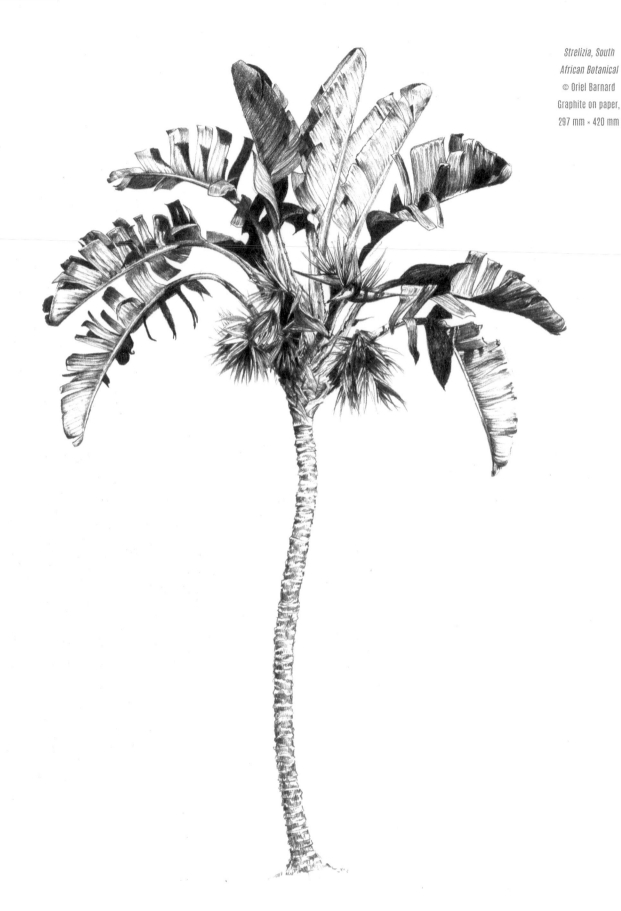

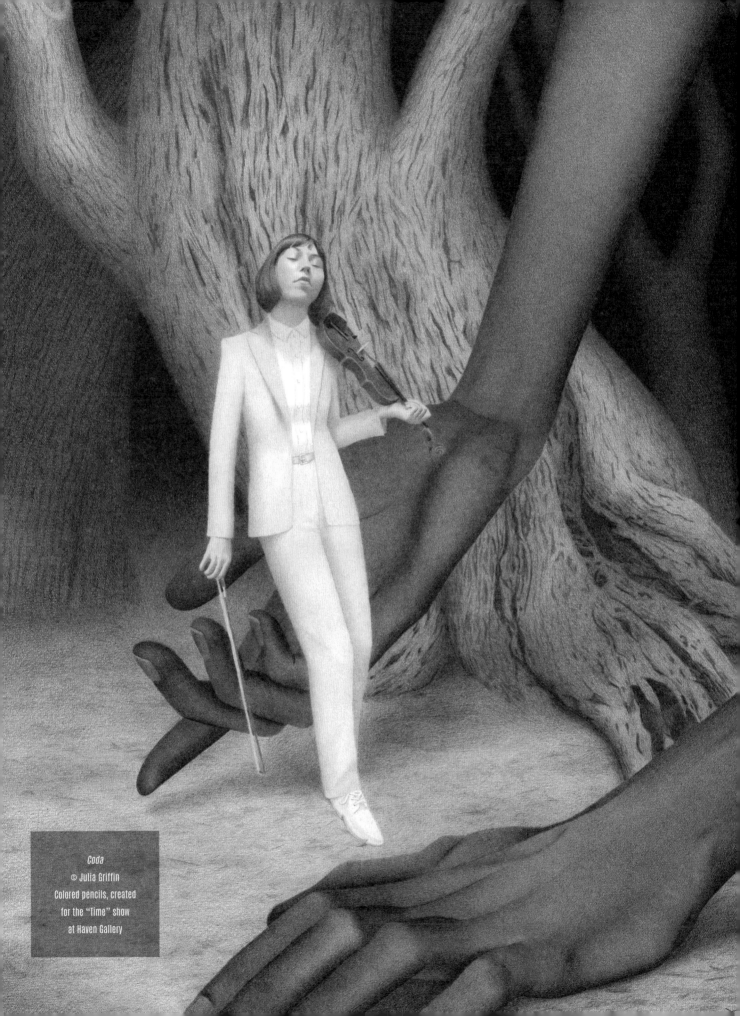

Coda
© Julia Griffin
Colored pencils, created
for the "Time" show
at Haven Gallery

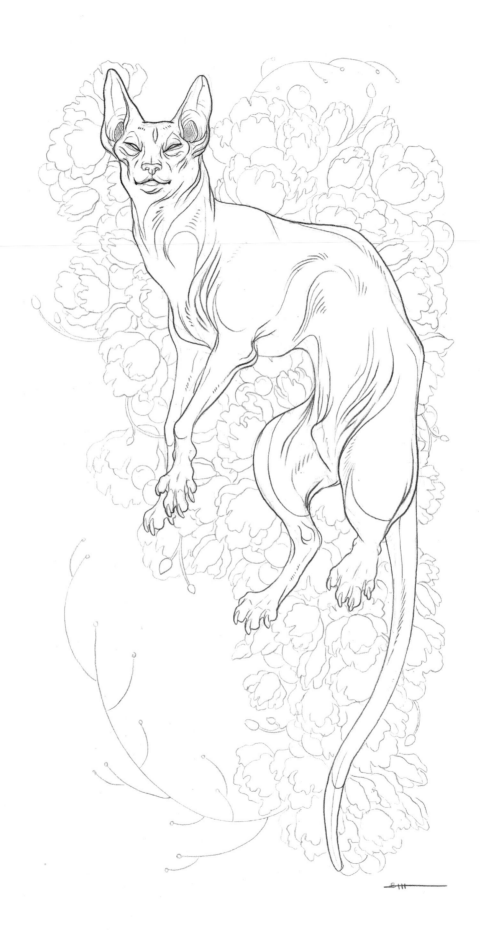

Pink Wrinkles
© Sarah Mason 2018
Pencil, ink, and
watercolor

Jericho © Laura Hines • Pencil and ink on Bristol

Prejudice
© GWAJA
Pencil and
gouache on paper

THE GALLERY CONTRIBUTORS

 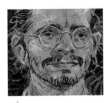

L Filipe dos Santos is a Portugal-based artist who has been working in illustration for about a decade, both on personal projects and commercial or editorial works. He is very interested in exploring the expressivity of color and gestural drawing

corcoise.net

Oriel Barnard lives in Cape Town, South Africa, working as an independent illustrator, fashion designer, and visual artist. Her illustrations are a glimpse into wondrous worlds and their creatures, capturing a moment in time always there to revisit.

instagram.com/oriel_barnard_illustration

 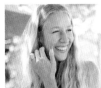

Julia Griffin graduated with a BFA in Illustration from the School of Visual Arts. She is based in New York City, and specializes in mythology, fairytales, and meticulous pencil rendering. She recently self-published a re-telling of *The Snow Queen* by Hans Christian Andersen.

juliagriffinart.com

Sarah Mason is a UK-based freelance artist. Using an array of mediums such as pencils, inks, watercolor, and gouache, she creates art that blends strong traditional techniques with contemporary themes, gravitas and whimsy, lines, and colors.

artbysarahmason.com

Laura Hines is an illustrator living in Flagstaff, Arizona. She is currently a resident artist at Creative Gateways (Sedona, Arizona), and a freelance illustrator with Easle (London, UK).

laurahines.net

GWAJA is a contemporary artist based in Seoul, Korea. Ever since she was young, she has been a shy and timid person, and drawing pictures became a way to communicate and express her ideas and feelings with real freedom.

instagram.com/gwaja.j

HOW TO SUBMIT

Please send a link to your portfolio or some examples of your work to info@graphitemag.com

BEAST OF BURDEN

A narrative illustration project with Mickael Balloul | Story by Adam J. Smith

"The Salvage Man had no name. He crossed the flat plains of the dried-out seabed, dodging through canyons and climbing rocky mountains on his solar-powered mech. His solarized parasol kept him cool, and his trailer-mech piled high with scavenged tech lumbered heavily behind. It was a thankless life, with the sun beating down and the wells drying up – but the settlements he traded with were grateful, and they did not attack him, for he was The Salvage Man, and no-one else wanted his job."

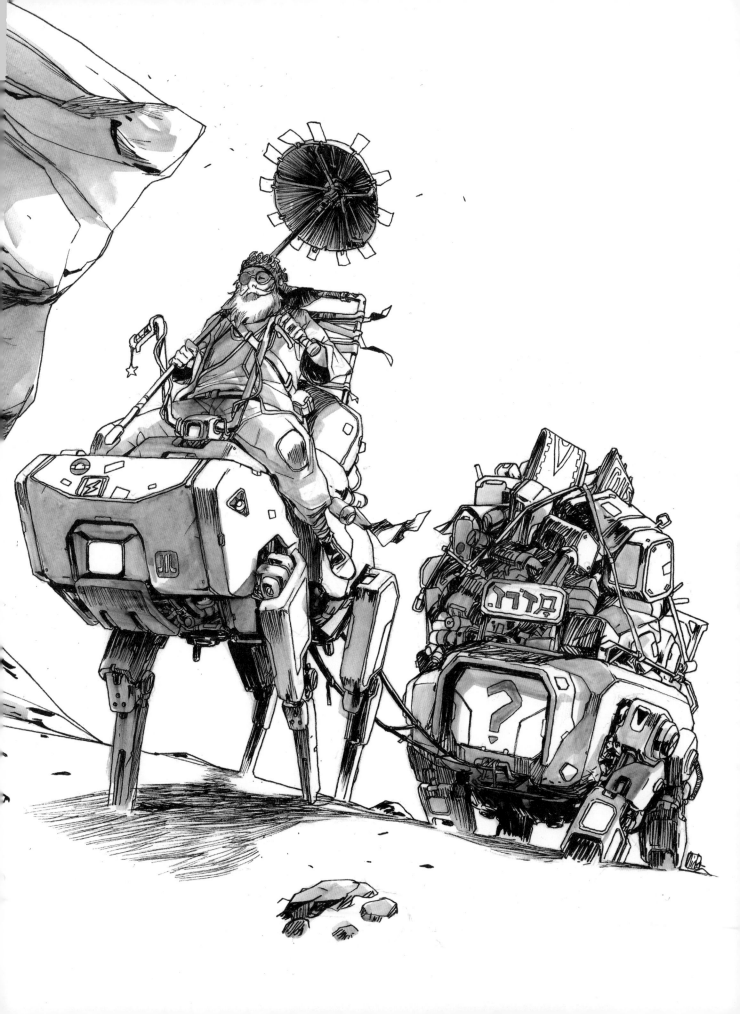

Join concept artist Mickael Balloul as he illustrates a sci-fi scene of a roving merchant, from rough character sketches to a final inked drawing.

Initial sketches

In this tutorial I will show my process for making an illustration from the first sketches and thumbnails to a final drawing. The image will depict a desert merchant traveling with a loyal beast of burden, in a sci-fi setting. The tools I will use are a Col-Erase pencil (in Scarlet Red), a Tombow Fudenosuke pen (WS-BS 150), and a Pentel brush.

I start by sketching some random faces in pencil to warm up. Cyberpunk is the type of sci-fi that I like most, and I want to mix that with a slight Bedouin influence to reflect the desert setting. The character will be slightly rough, dressed in used clothes and some junk items such as old badges. My goal at this stage is to define a broad direction for the merchant, not to design the character completely, because I want to keep some freedom during the making of the illustration.

"My goal at this stage is to define a broad direction for the merchant, not to design the character completely, because I want to keep some freedom during the making of the illustration"

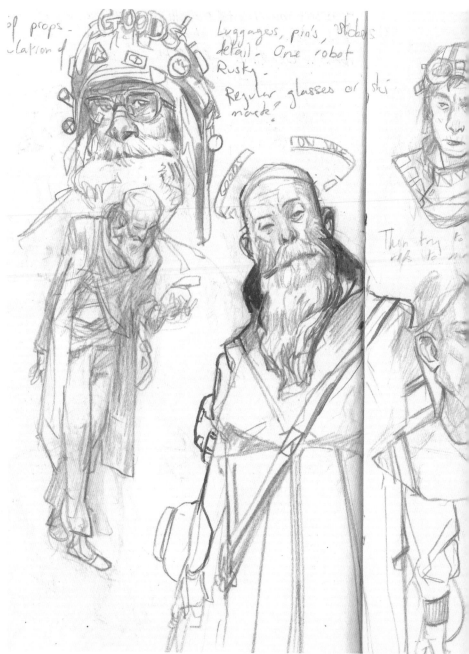

Beast of burden sketches

I also make some rough pencil sketches for the merchant's beast of burden, working out what kind of beast I will draw. Because the desert theme is very much present in my mind, I start out with a mutant or alien camel, and some other types of organic creatures carrying heavy loads of merchandise. However, when I look at the sketches I've made for both the merchant and the beast, I feel I am missing a sci-fi element. I decide to opt for a robot beast instead, though I retain some of the mammal-like inspiration for its size and shape.

Far left: Sketchbook and tools

Near left: Early character sketches to find a broad direction for the desert merchant

Below: Sketches for the beast, exploring organic creatures before switching to a mechanical design

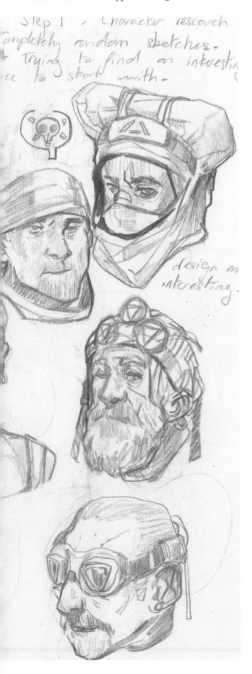

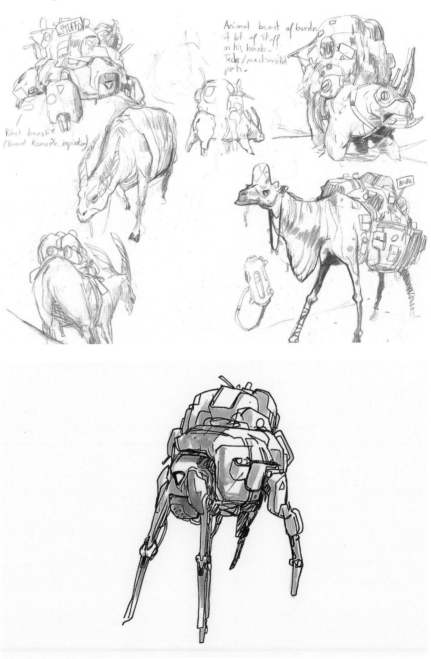

"I want to put the emphasis on the "travel" aspect of the story"

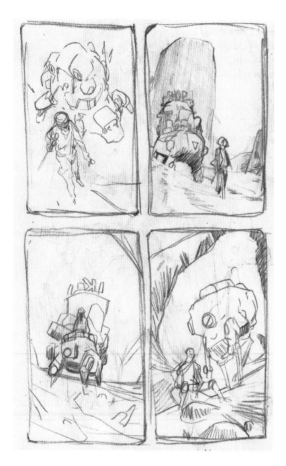

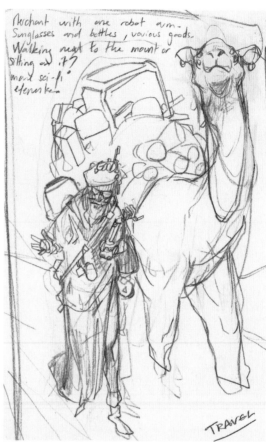

Left and near top right
Thumbnail sketches to find the right composition for the illustration

Far top right
The final composition sketch, drawn in pencil

Near middle right
Reworking the posing and proportions of the merchant

Bottom right
Developing the design of the mech beasts

Thumbnails

Once I have a rough idea of the characters I want to draw, I start to consider the composition of the illustration. At this stage I try out different points of view and poses that might make the scene more dynamic. I discard the static compositions, such as the character standing in front of the beast or sitting on a rock, because I want to put the emphasis on the "travel" aspect of the story.

Composition sketch

I decide on a low-angle composition with the merchant travelling seated on his mount, leading the way for his beast of burden. I could have placed the merchant and the merchandise on the same mount, but I want to keep the distinct silhouette of the character, and the image might become too busy and overly detailed if there is too much behind him. This pencil sketch is still very rough, but the main shapes and ideas are now defined. However, I would still like to improve and refine some aspects.

Refining the character

Now that the composition is decided, the first thing I want to adjust is the merchant's pose. The character looks slightly too big compared to his mount, for my taste. I change the positioning of his legs to emphasize the fact that the character is actually riding the robot instead of just sitting on it. In the same spirit, I decide to add some motorcycle handlebars that allow him to direct the robot, making the character feel more active in the scene.

Refining the robots

Now I will refine the designs of the merchant's two robots. For the mount robot, I want a design mainly covered with metal plates, with some parts that are left open to expose some interior cables and other mechanical parts. The idea behind this is to show that this robot has had a long life and is rarely taken care of.

I design the "beast of burden" mech as a larger, thicker machine, able to carry a lot of weight. Despite its difference in stature, I keep its visual shapes similar to the mount, creating consistency in the image. I want its heavy cargo to have a very messy aspect, so I draw a large pile of boxes and pieces of junk stacked together randomly, giving the impression that it could crumble at any moment.

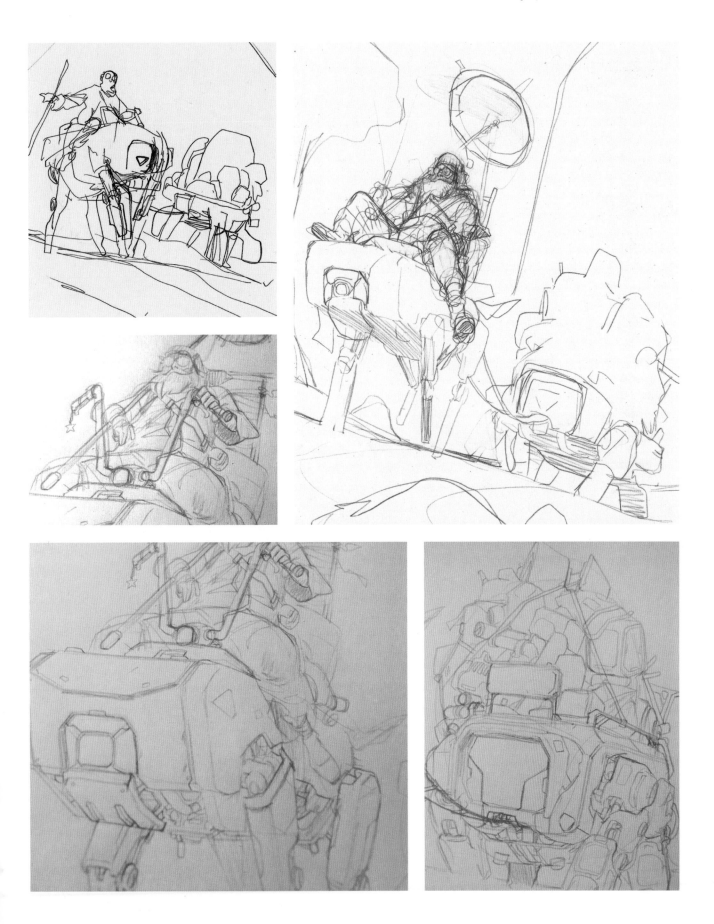

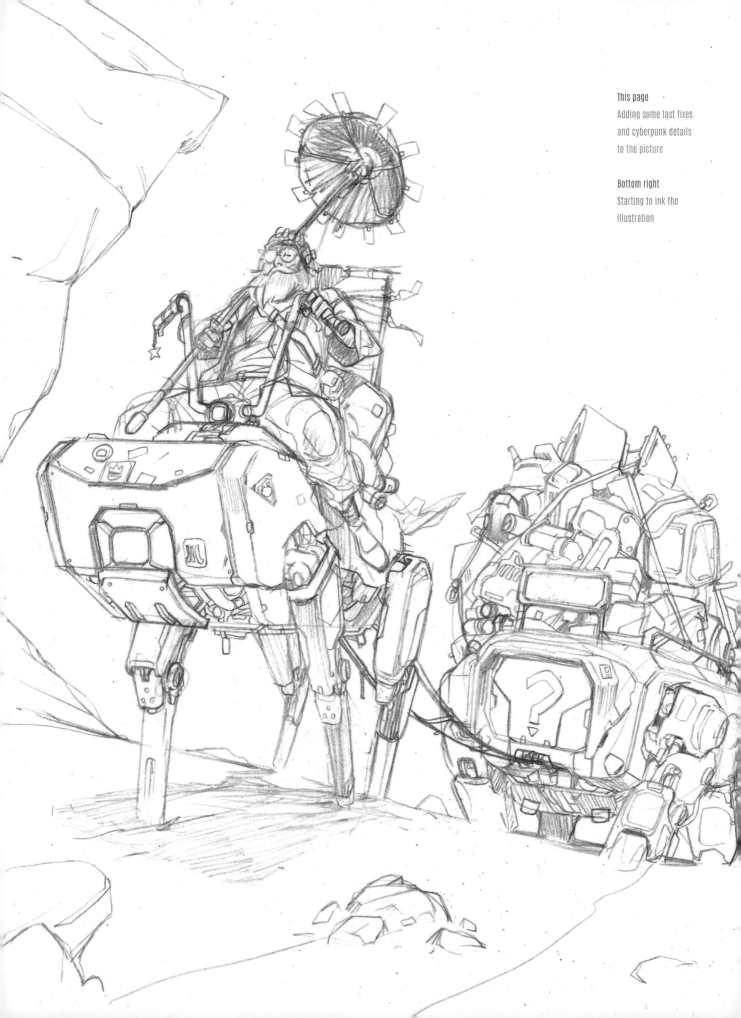

This page
Adding some last fixes
and cyberpunk details
to the picture

Bottom right
Starting to ink the
illustration

ARTIST'S TIP

Scanning

I scan my drawing so that I have a digital backup in case I mess up during the inking stage. If you make a mistake but still have a copy of the original sketch, at least you do not have to start from scratch. I quickly desaturate the picture in Adobe Photoshop by opening the Levels menu and dragging the black slider towards the gray area. This leaves me with a very low-contrast picture, just visible enough to ink on top of it, but faint enough that it will not be prominent in my final picture when I scan it. I print a copy of this to ink directly onto, but if you do not have digital tools, you can achieve a similar effect by tracing lightly over your original sketch with a lightbox.

Final sketch

Once the main shapes are in place, I continue detailing the sketch, adding some stickers here and there on the robots to push a rough cyberpunk feel. I also change the position of one of the merchant's hands to make him hold the parasol. I also lay out some rough shadow information that will be useful when I am inking later. I finish my sketch by suggesting the desert environment with some rocks in the foreground.

Inking the merchant

Now I can begin inking the picture. I start with the character's face, as I often do, because it's the most tricky part for me. This avoids the frustration of working on the entire picture, or a large amount of it, and then messing up the face at the last minute. Only when the face is complete do I continue with the rest of the character.

For this line art I use the Tombow pen – a type of brush pen similar to the Pentel brush, but with a tip that is not as soft. This allows me to change the thickness of the line somewhat, but with much more control, and takes much less practice. It requires a lot of practice and a gentle touch to create similar precise lines with a Pentel brush, and I'm not gentle at all when I'm drawing!

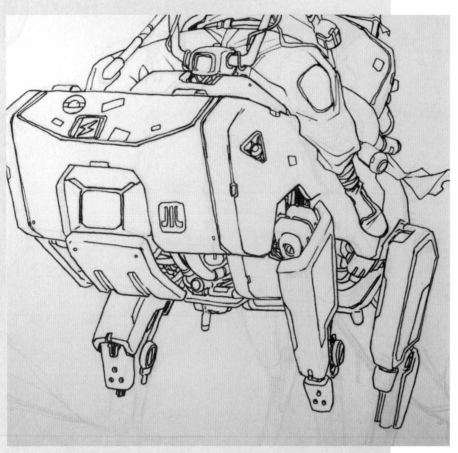

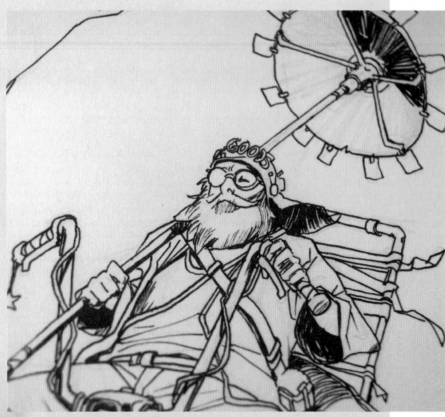

Top left
Now it's the robot's
turn to be inked

Right
Completed linework

Bottom left
Shading the illustration
with hatching to give
volume to the shapes

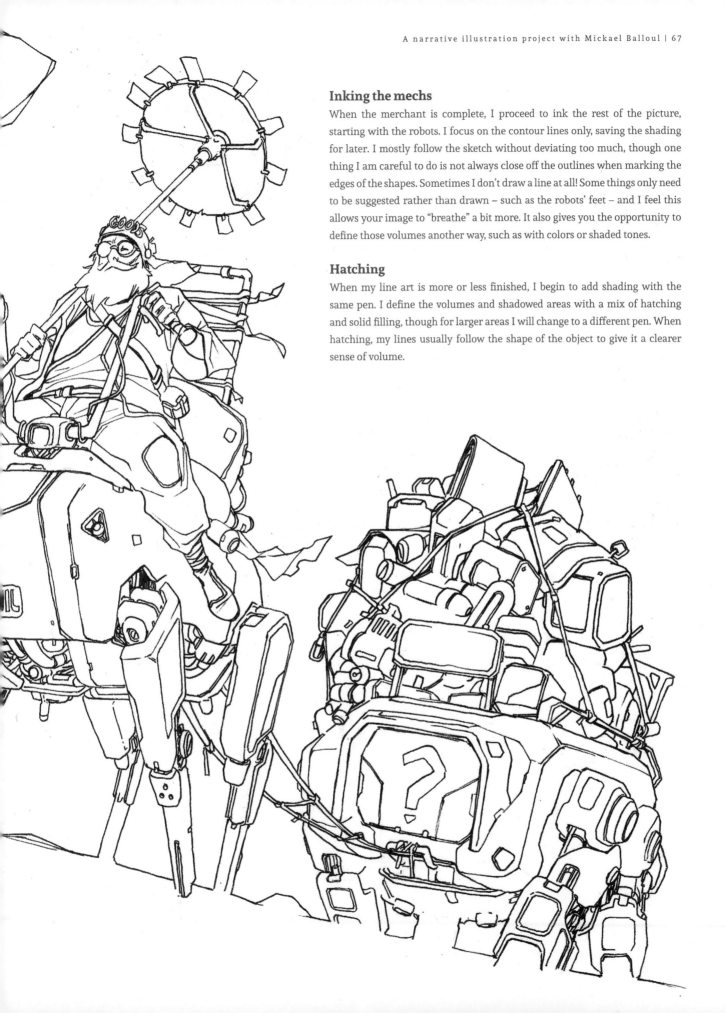

Inking the mechs

When the merchant is complete, I proceed to ink the rest of the picture, starting with the robots. I focus on the contour lines only, saving the shading for later. I mostly follow the sketch without deviating too much, though one thing I am careful to do is not always close off the outlines when marking the edges of the shapes. Sometimes I don't draw a line at all! Some things only need to be suggested rather than drawn – such as the robots' feet – and I feel this allows your image to "breathe" a bit more. It also gives you the opportunity to define those volumes another way, such as with colors or shaded tones.

Hatching

When my line art is more or less finished, I begin to add shading with the same pen. I define the volumes and shadowed areas with a mix of hatching and solid filling, though for larger areas I will change to a different pen. When hatching, my lines usually follow the shape of the object to give it a clearer sense of volume.

Filling larger areas

I switch to shading with the Pentel brush so that I can easily fill larger areas with black. Having some fully black areas creates contrast with the hatching, and clearly represents the areas where the shadows are supposed to be stronger or deeper. This is why the pure black areas are mostly limited to areas such as the robots' undersides and the insides of the merchant's sleeves.

Adding details

I continue to add a few details here and there during the shading process. For example, I define the rocks more, and add some lettering and little patterns to the robots and cargo. In the end, it's these little things that help to tell more of the characters' story.

Marker shading

The illustration is mostly finished, but I would like to add more contrast and definition. I choose a gray marker (a fairly light gray ShinHan Touch Twin) and use it to apply an extra layer of shading. I have already established that the light source comes from above and slightly behind the characters, so I shade the lower front parts of each element. I keep the general direction in mind without worrying about being 100% accurate, to maintain a sketchy quality.

Final illustration

Last of all, I use my Col-Erase pencil to color some details in red. This makes them "pop" more, highlighting sci-fi elements such as the sunglasses, logos, and typography, and adding extra visual interest to the image. Now this cyberpunk merchant and his robot beast of burden are complete.

Top left and above
Using the Pentel brush to
fill larger areas and create
more contrasting shadows

Bottom left
Another layer of shading
adds more contrast
to the illustration

Right
Final image
© Mickael Balloul

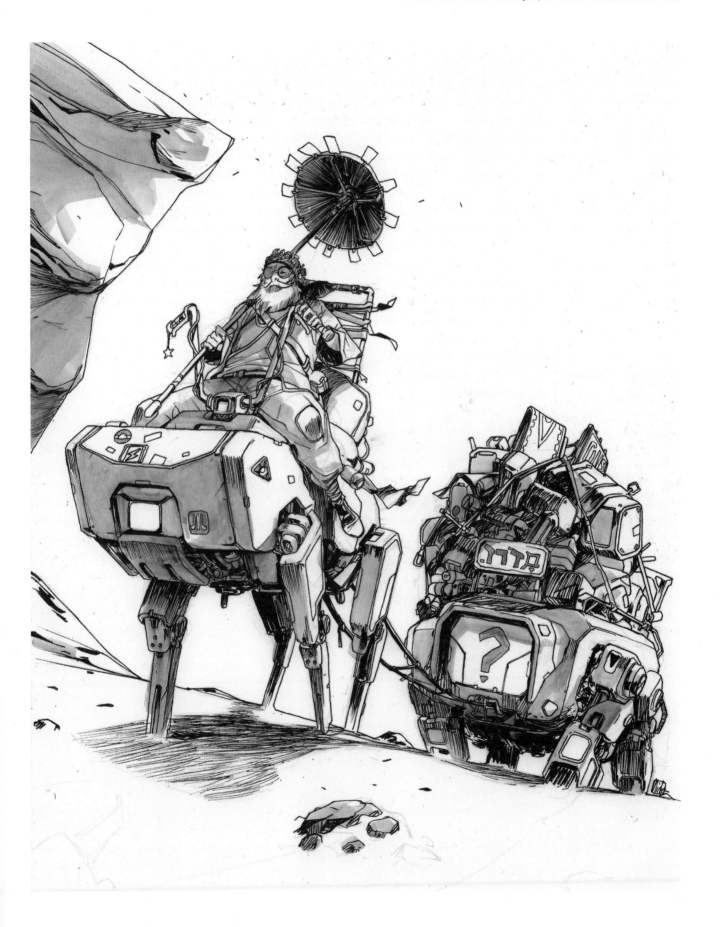

ART AND ARCHITECTURE

An interview with Maja Wrońska

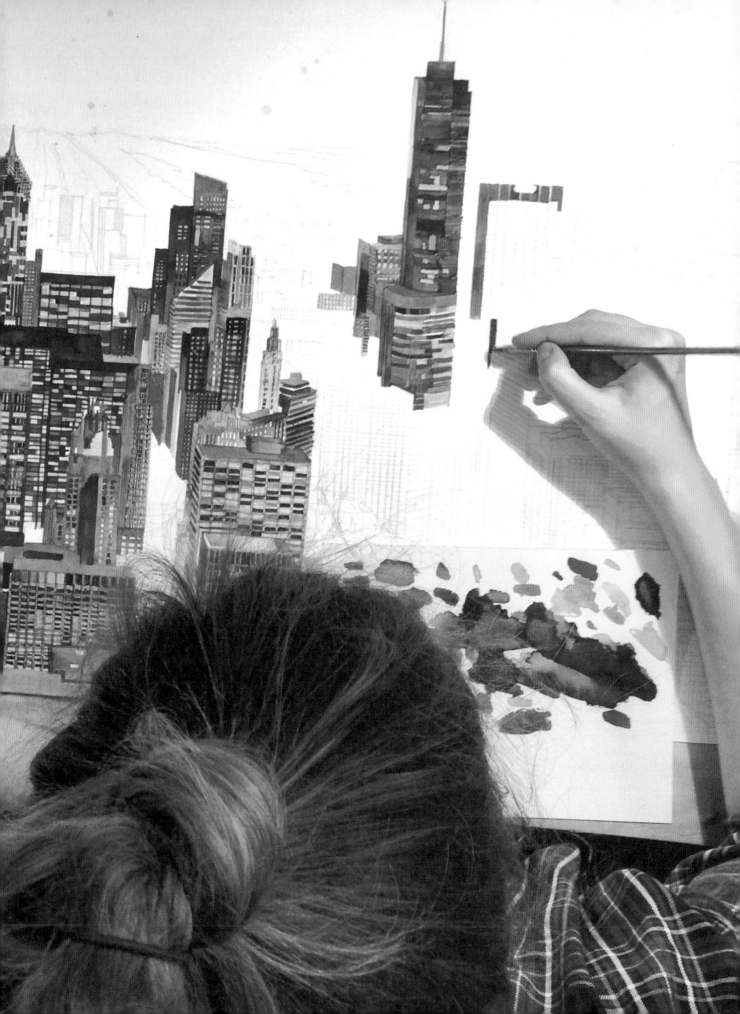

Illustrator and architect Maja Wrońska is well known for her richly detailed watercolor scenes and precise drawings of locations from around the world. We learn more about her work and inspirations in this interview.

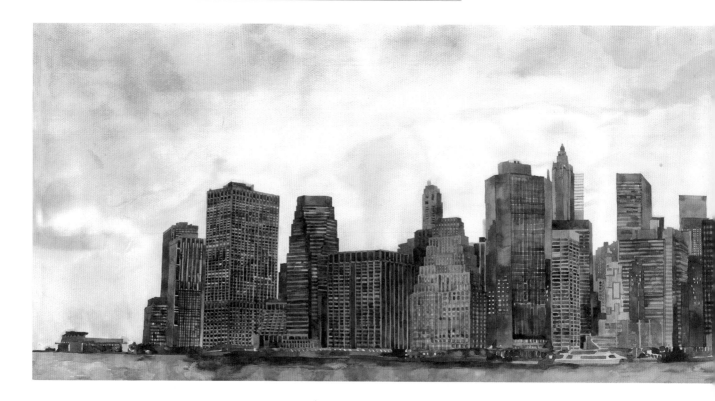

Q· Thank you for speaking to GRAPHITE, Maja! Could you please introduce yourself with a bit about what you do and where you are based?

A· I am an architect from Poland, where I started my own business after graduating with an architecture degree from the Warsaw University of Technology.

My mother designs architecture, mostly in the Mazovian Voivodeship (Mazovia Province) in Poland; my husband Przemek is also an architect, focusing on architectural renderings, and I am a partner of his studio thisisrender.com. I work with both of them as an architect, while also working as a freelance illustrator, painting with watercolors and creating illustrations for companies from all around the world. For example, I created a motif for IKEA's GRÖNBY set, and a series of my illustrations are also available to

download and color on the Lake coloring app. I'm trying to achieve a new approach to the traditional technique of watercolor, showing a modern way of using it.

Q· Who or what inspired your love for architecture and art?

A· My mother is also an architect, so she introduced me to all her professional painting and drawing tools when I was a child. My journey with art and architecture started then. When I was four years old, she let me color the facades of buildings she designed, and would show my drawings to actual clients. I was very good at this, and sometimes they didn't realize that one option was colored by a four-year-old!

I have painted for around fifteen years now, so the results usually turn out well when I just create the paintings or illustrations as

instructed by the client. However, my work is better when I am feeling really inspired by the place or topic, or by photos, music, movies, and TV, and I feel more proud of the results.

Above
The finished panorama of New York City. Some of Maja's images can be purchased through society6.com/takmaj

Right
Painting a panorama of New York City

"I'm trying to achieve a new approach to the traditional technique of watercolor"

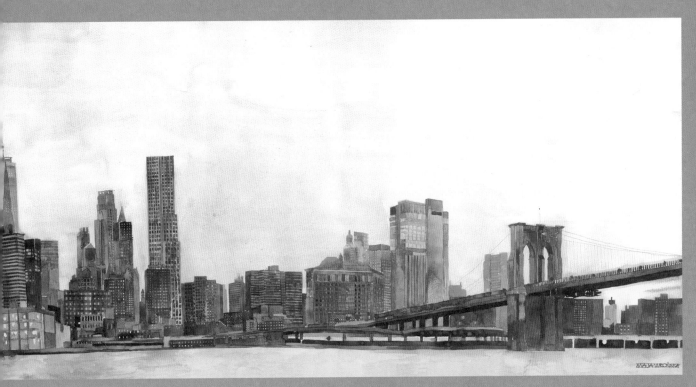

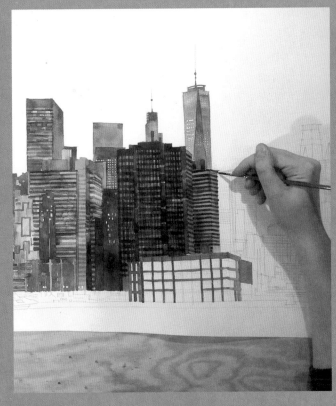

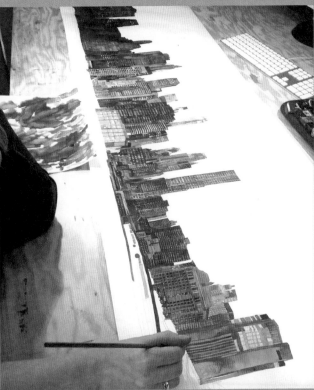

Q· What are some of your favorite places to draw or locations to work?

A· My favorite location to draw is my studio – I have painted many times outdoors, but I usually get sunburn! I am easily distracted, so when people come to see what I'm drawing, it's hard for me to focus. When I was painting the Old Town in Warsaw, a pigeon dropped some old ham on my drawing. So yes, painting outdoors is fun, but I prefer drawing in my studio.

Q· Your subject matter is often very complex and watercolor can be a tricky medium. What is your process for planning and creating a watercolor painting?

A· I chose to work with watercolor because it is usually considered one of the most demanding mediums. Watercolors are harder to use than acrylics, where you can always paint one more layer, or pencil that you can erase. The technique I use does not allow me to change the painting over and over; when I paint something once with watercolors, it stays that way.

If I am required to paint an actual place, I search for some reference photos with a CC0 Creative Commons license first. If I am painting something imaginary, I make a small sketch to plan all the components of the image. Then I usually plan the color scheme of the painting in Adobe Photoshop.

I make the base sketch with a 5H pencil because it doesn't smudge. When the sketch is finished I usually scan it to preserve it, and then I paint it with watercolors. I sometimes animate the sketch and final painting, or I record the painting with a GoPro camera to make a process video.

These pages
Sketches and works
in progress of
Cologne Cathedral

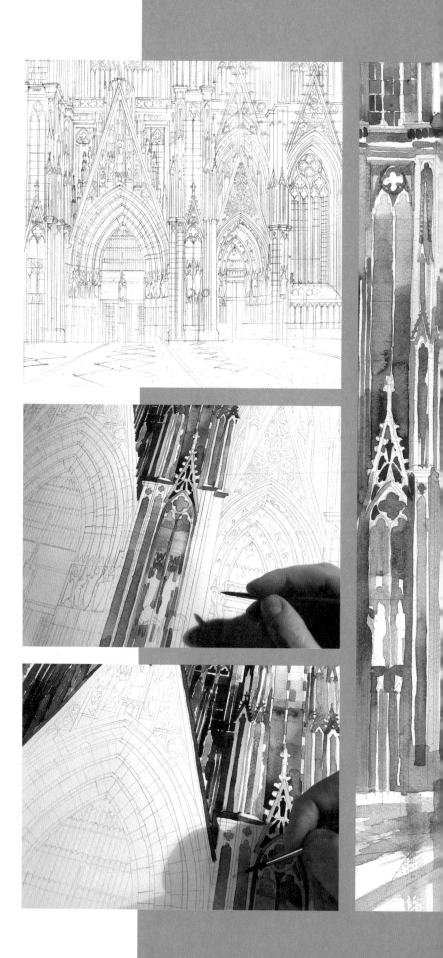

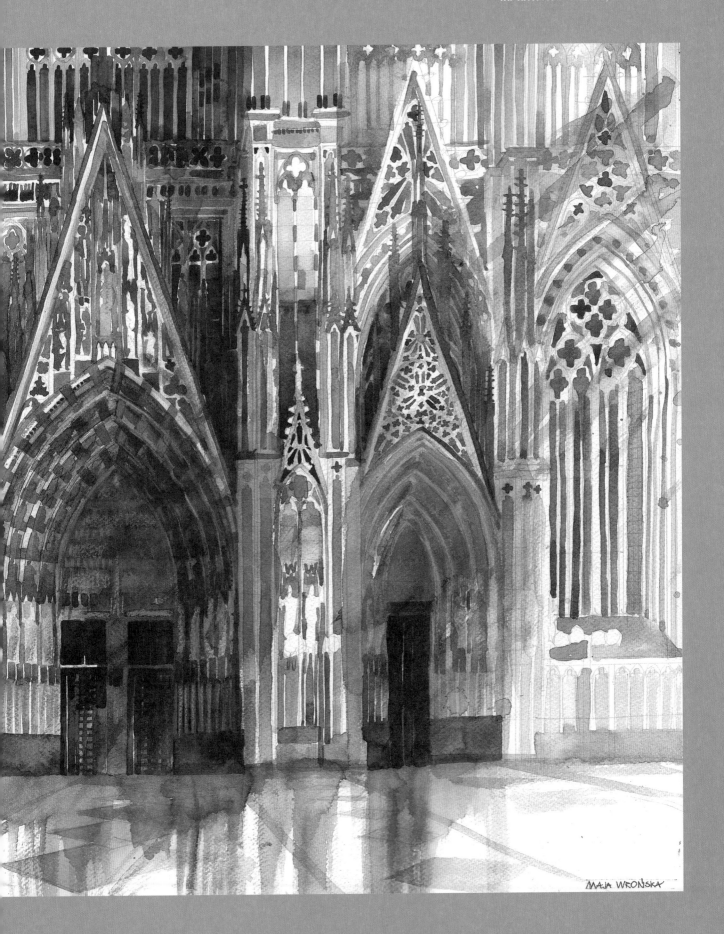

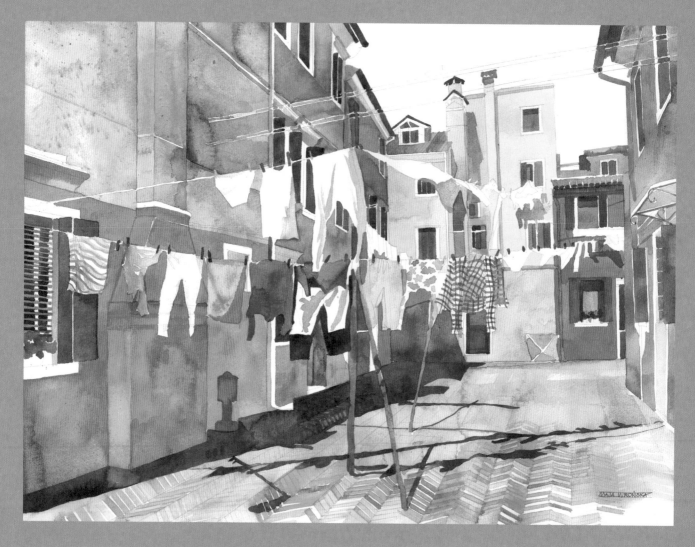

Q· What materials do you prefer to work with? What tools would we find in your workspace?

A· I use Fabriano 300 gsm watercolor paper for my paintings; I buy large 10-meter rolls of it which can be cut to the required size. I use White Nights watercolors and Renesans watercolor brushes. I scan my works on an A3 Mustek scanner, but I usually paint on paper that is larger than A3, so I join multiple scans together in Adobe Photoshop, which I also use to adjust the colors to ensure they look like the original painting. I sometimes make digital corrections in Photoshop using the Astropad app, which enables me to use my iPad like a graphics tablet.

Q· What are some of the challenges and advantages of being a freelance artist?

A· I'm self-employed, and I like to tell people that I have my own company! I like that I can be my own boss; I am not a person who can work from 9 to 5, then leave the office and all their work behind. I think that when a person likes their job, work is something they can do with pleasure, and even sometimes for fun. Having a boss telling me what to do is something that automatically frustrates me, but it's different working as a freelancer with different clients. Even when a freelance collaboration is difficult, you know you can stop for a while and work on something else, then come back to the project with a calm and fresh approach.

When working as a freelance artist, it is not obvious how much money you earn each month. It's challenging and can be exciting;

on one hand, it is almost entirely up to you how much you can earn, but on the other hand it can be stressful when you don't have any new projects. Finding freelance work relies strictly on social media and networking; without social media and the internet in general, it is difficult to be found by a client or to search for new clients.

Above
Laundry in Venice

Right
A painting of Cinque
Terre, Italy

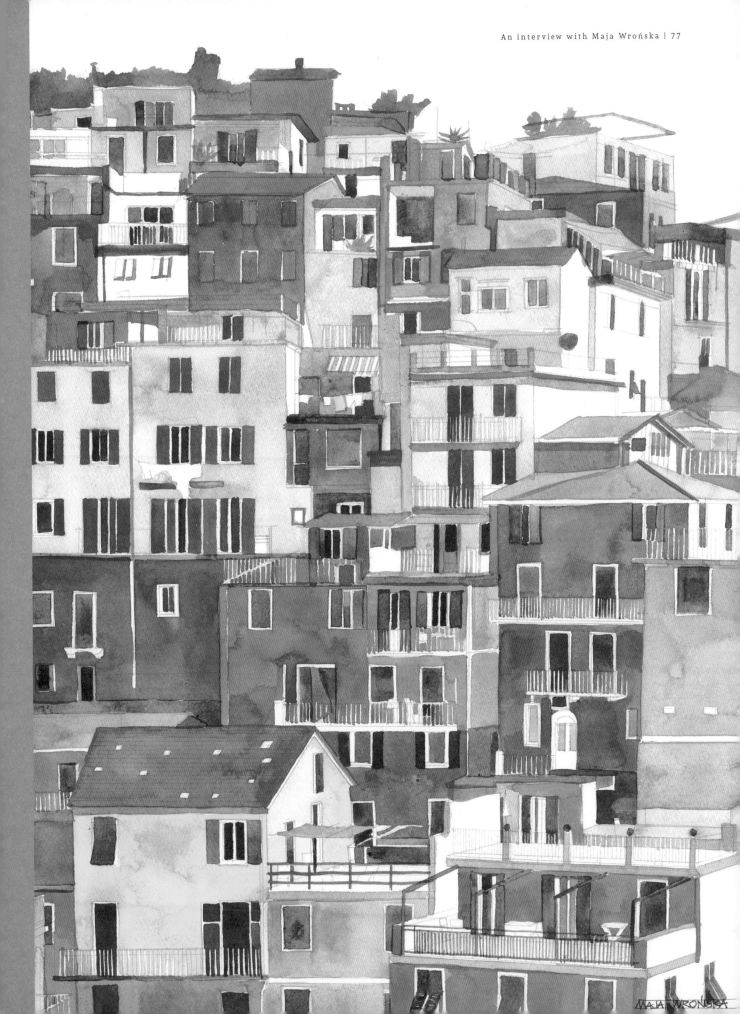

"I think it's also useful to know digital software, even if you are a traditional artist"

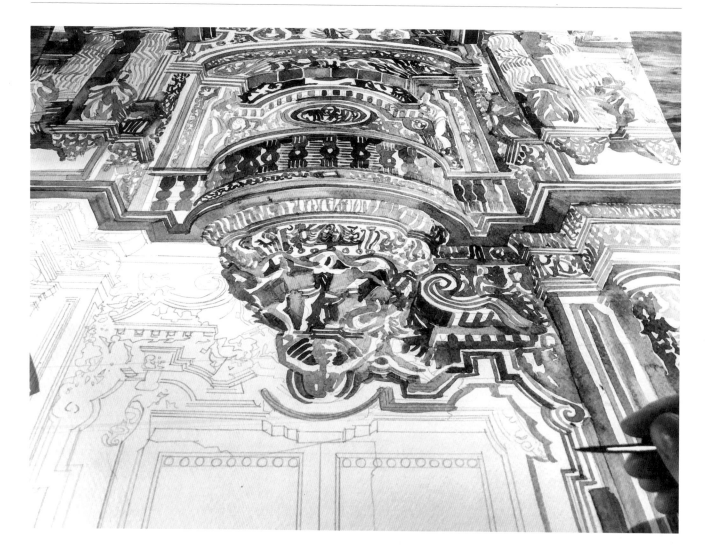

Q. What advice would you offer to people aspiring towards a career in art?

A. Some of this advice can relate to many careers, art-related or not. First of all, if you're not a native English speaker, you should learn English to be able to communicate with a larger audience.

Next, you will have to make decisions about who you want to work with, and how much time you can invest in a particular area of your art. Knowing laws and regulations is also essential. Learn about copyrights; it's really important to be able to understand the agreement you just signed, at least in general. Sometimes asking a lawyer for advice while signing an important agreement is recommended.

I think it's also useful to know some digital software, even if you are a traditional artist. If you plan to work as a freelancer in any medium, you must learn about social media and digital marketing too.

Q. What do you like to do when you are not making art?

A. I like spending time with my family the most. I am also a total TV freak, with a subscription for every possible on-demand TV service in Poland. My watercolors hang on the sets of several shows, including *Santa Clarita Diet*, *Gotham*, *Pretty Little Liars*, and *Uncle Buck* – so sometimes watching TV can be a little art- and work-related too!

These pages
Watercolor painting
of the entrance to the
Palace of San Telmo

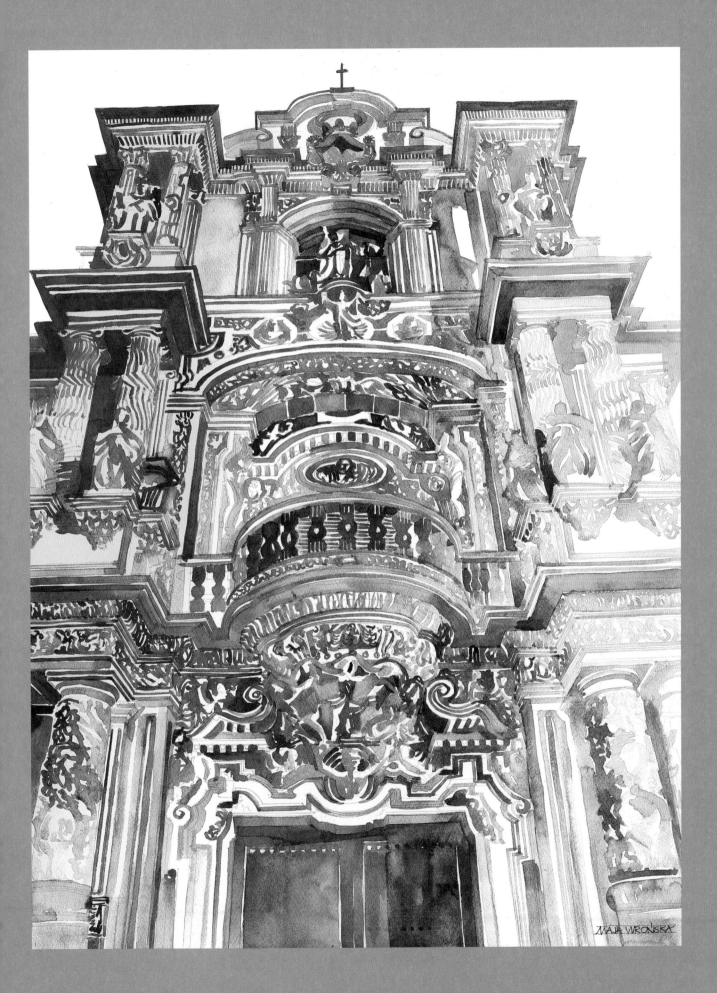

MAJA WRONSKA

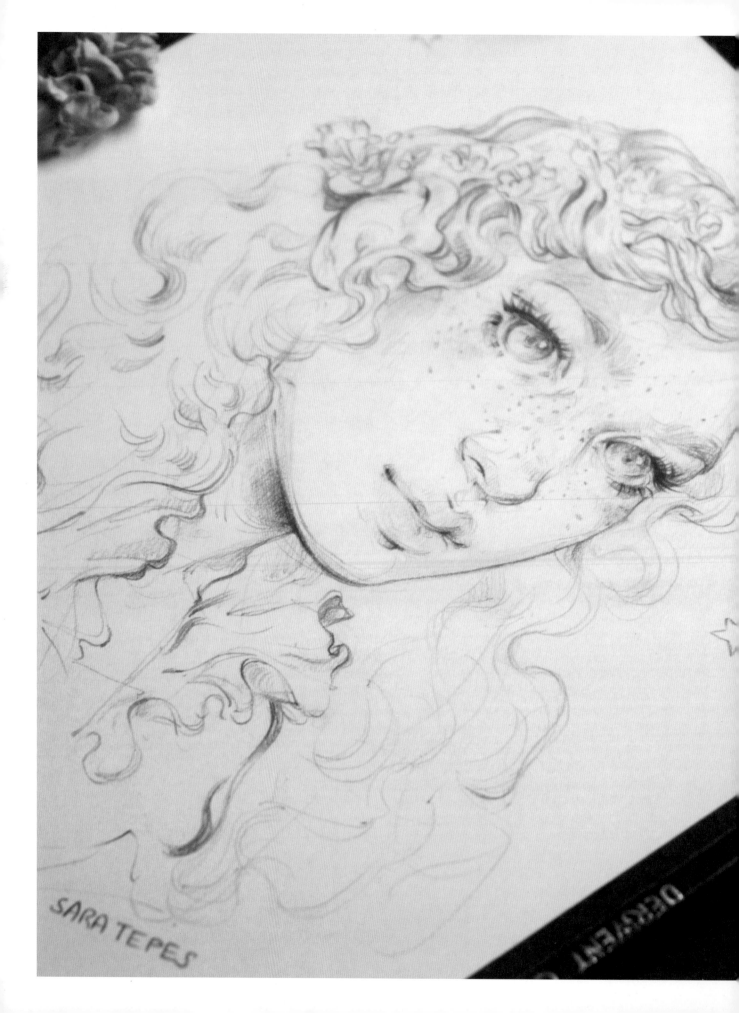

SARA TEPES

DERWENT

ETHEREAL PORTRAITS

Sketching a character in pencil with Sara Tepes

Learn how to sketch an elegant character portrait using a simple pencil, a putty eraser, and this guide by freelance artist Sara Tepes.

Left
Recommended materials
for this project

Top right
Brief thumbnail ideas

Near bottom right
Loosely defining the subject

Far bottom right
Roughly placing the
facial features

In this tutorial, I am going to explain the general process that I go through when drawing a portrait of a woman in pencil. I use a combination of minimal strokes and varied pencil pressure to create wispy-looking lines, while still keeping a defined structure to the piece. Feel free to use reference photos for your drawing; I am drawing this character from my imagination.

Materials

You can use any pencil and paper for this project; don't be discouraged from using copier paper and mechanical pencils for practice. However, I highly recommend using Strathmore 400 Series marker paper for this tutorial; it is very smooth and helps the pencil glide across the surface effortlessly. I will use

a Derwent 9B pencil for this drawing, but alternatively, you can use a mechanical pencil with a soft grade. A kneadable putty eraser keeps eraser dust off your drawing, which can minimize smudging, and a pencil sharpener is necessary for keeping your lines crisp.

Thumbnails

I sketch some brief thumbnail ideas and settle on the second character shown here; the thick wavy hair, flowers, and open eyes will offer lots of opportunities to explore different shading and line qualities.

On my Strathmore marker paper, I begin by drawing a couple of quick lines defining where the head, hair, shoulders, and any other elements will be placed on the page.

This sketch is extremely rudimentary and only serves to show if you have centered the subject on the page and if all the elements will fit. Use very light strokes for this.

Placing the features

I define the basic face shape and then start placing the facial features. I begin with a rough outline of where the nose will be and then move on to the eyes and lips.

Place the corners of the eyes before drawing in the lids and pupil; the inner corner of the eye will line up with the outer corner of the nose, so be sure not to position the eyes too close in or too far out. Lastly, sketch in an ellipse for the ear. None of the features are detailed at this point.

"Don't be discouraged from using copier paper and mechanical pencils for practice"

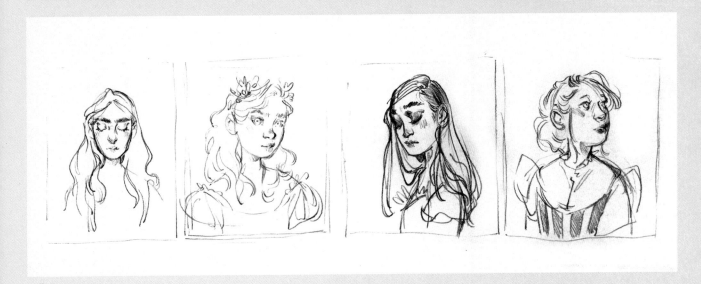

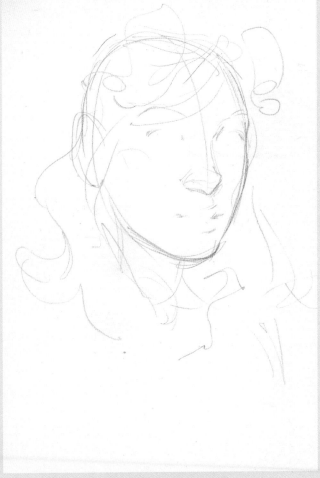

"Use light pressure when defining the shapes of the eyes"

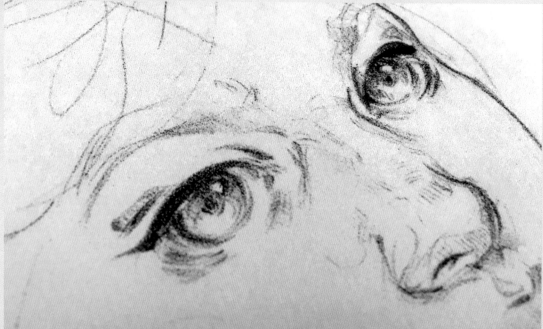

Far top left
Defining the nose

Near top left
Blocking in the shapes
of the eyes, pupils,
and eyebrows

Near left
Adding details to the eyes

Near right
Drawing the lips

Far right
Adding some eyelashes and
soft shading on the face

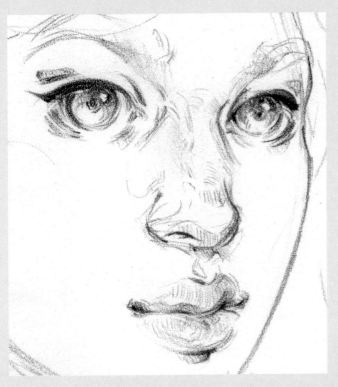
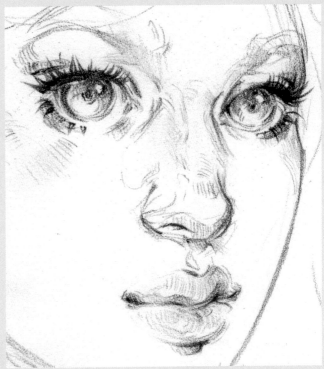

Starting with the nose

Now we can start rendering the drawing. Begin with the nose; use light pressure with your strokes and then build up more heavily once you are confident with the placement of your marks. Keep the lighting in mind, using lighter lines for areas that are brighter and darker lines for areas that are overshadowed. Consult your reference image, if you're using one, or look up lighting references now if needed. Use the septum as a guide for where to draw the philtrum (the groove beneath the nose) and Cupid's bow, and then draw the bridge and sides of the nose.

Sketching the eyes

Use light pressure when defining the shapes of the eyes. When working with a three-quarter perspective such as this, it can be difficult to get your drawing to look cohesive and anatomically correct, so do not be afraid to use references, erase, and redraw a couple of times. Use heavier pressure for the corners of the eyes, but don't define the waterline too much, unless you want your character to look like they are wearing eyeliner. Block the arch of the eyebrow in; this will aid you

when deciding the direction that the hairs will go in. Lastly, feel free to erase any of the remaining base sketch lines if they are getting in the way of your details.

Detailing the eyes

Now let's add some details to the eyes. Draw shapes for the highlights and shade around them, leaving them blank. The results will pop more than if you would have shaded in the whole eye and then erased an area for the highlights. Keep the shadows around the tops of the pupils if you are using an overhead lighting scenario for your portrait; the eyelids will overshadow the top half of the eyes, so make sure to also faintly shade in the tops and corners of the whites of the eyes.

You can also add some detail to the under-eyes, such as eye bags and shadows under the lash line, to give the portrait more realism.

Shading the mouth

Start by defining the center of the lip and the corners of the mouth, and then begin shading. Remember that both the upper and lower lips curve inward into the mouth, and

the point where they meet will be in shadow. Do not define the edges of the lips unless your character is wearing lipstick. Use curved vertical strokes to emulate the form and texture of the lips, and add a shadow under the bottom lip. Lastly, add soft shading to the corners of the mouth to suggest more form in the character's lower face.

Adding eyelashes

Once all the facial features have been defined, it is time to add the eyelashes. Make sure to sharpen your pencil for this, if you are using a wood pencil. Press a little harder at the base of the lash and pull up, lifting the pressure as you draw each lash. Making the lashes in the middle of the eye a little bit shorter will help with creating dimension; it's as if the lashes are pointing toward the viewer and thus appear foreshortened.

At this stage I also begin to add some shading to the cheeks and cheekbones, barely smudging these areas with my finger to give a soft appearance of blush; you can use a tortillon or cotton swab for this if you don't want to risk getting any skin oils on the piece.

Filling in the eyebrows

For the eyebrows, use references or your own eyebrows to understand the way the hairs flow. Use crisp lines deliberately to suggest their direction; usually, the hair on the inner portion of the eyebrows will stick up and out, while the rest of the brow hairs flow in a similar direction.

At this stage, I also add some more shadows under the neck and around the face. The highlights on the eyes suggest that the light source is slightly off-center for this subject, so I add faint shading to the perimeter of her face. Use combinations of light lines that are close together, thicker lines, and gentle smudging to keep interest in the piece.

Starting the hair

Treat the hair as big chunks rather than individual strands. The best part of drawing from your imagination is letting the hair do its own thing; I like to make it bouncy and not too subservient to the rules of gravity. Use a variety of pressure in each line; I start off with heavier pressure and then lighten it as I continue the line. Move fast and don't focus on exact placement for each line, as that will make your lines shakier. I place lines closer together to suggest that they are further from the viewer, or farther apart as they get closer, suggesting different levels of detail.

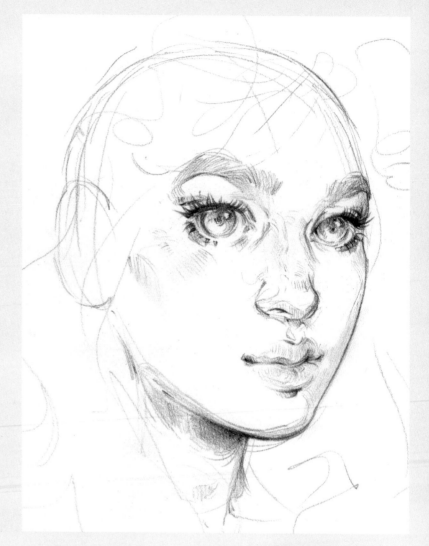

Near right
Defining the eyebrows
and adding more
shading to the face

Far right
Sketching in the hair
and figuring out the
direction it's flowing in

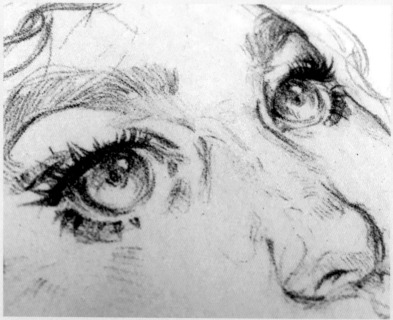

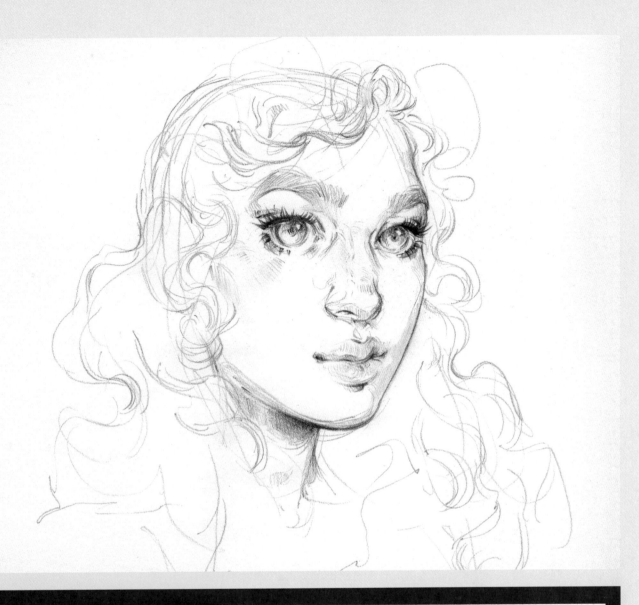

ARTIST'S TIP

Line weights

Use a variety of line weights in your piece. I use strokes that start with heavier pressure and then taper off to light points. Smudging can also add evenness to a piece; I personally like to combine the use of light lines and smudges, so that the smudged lines can still be visible. If you would like a completely smooth look, use a dull pencil or the side of your pencil and use light pressure to shade in circular motions, then smudge that shading to create an even gradient.

Further detailing

Once you know if the hair is going to be covering the subject's ear, begin to flesh the ear out; if you're unsure of the anatomy, look up some references or check your own ears in a mirror. Use the same concepts that you used for the previous steps: darker strokes on areas in shadow, curved shading lines to suggest a rounded surface, and slight smudging to soften the image.

Render the hair by using heavier strokes in areas where the hair is bending or in shadow. To create a realistic look, draw in the same direction that the hair is flowing. It will mimic the appearance of hair strands without requiring you to draw in every single line.

For the flower crown, depending on the level of detail you would like, you can either use reference or improvise it. I draw some squiggly lines that give the impression of a flower crown, or even a crown made of coral. Use your imagination and incorporate it into the strands of hair that you have drawn.

Finishing touches

Continue rendering the hair until you are content with the level of detail. I opt to keep the hair relatively loose at the bottom to give the piece a dreamy look, and to focus the viewer's attention on the character's face and eyes. Add any details and elements that you think will bring the piece together; I add a frilly collar, some freckles, a couple of decorative stars, and finally my signature.

Near top right
Rendering the ear and hair
and adding a flower crown

Far right
Adding the finishing
touches © Sara Tepes

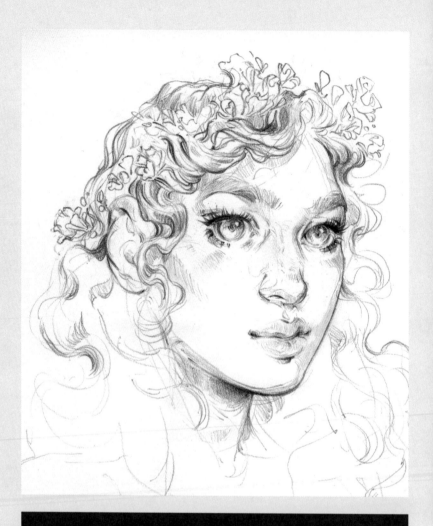

ARTIST'S TIP

Drawing freckles

Use a slightly dull pencil with light pressure and add random points and circles across the face. Freckles come in many sizes and aren't limited to the nose and cheeks, so feel free to add some size variations and bring them up to the character's forehead or jaw and chin.

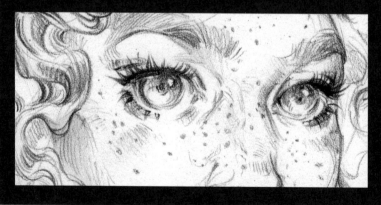

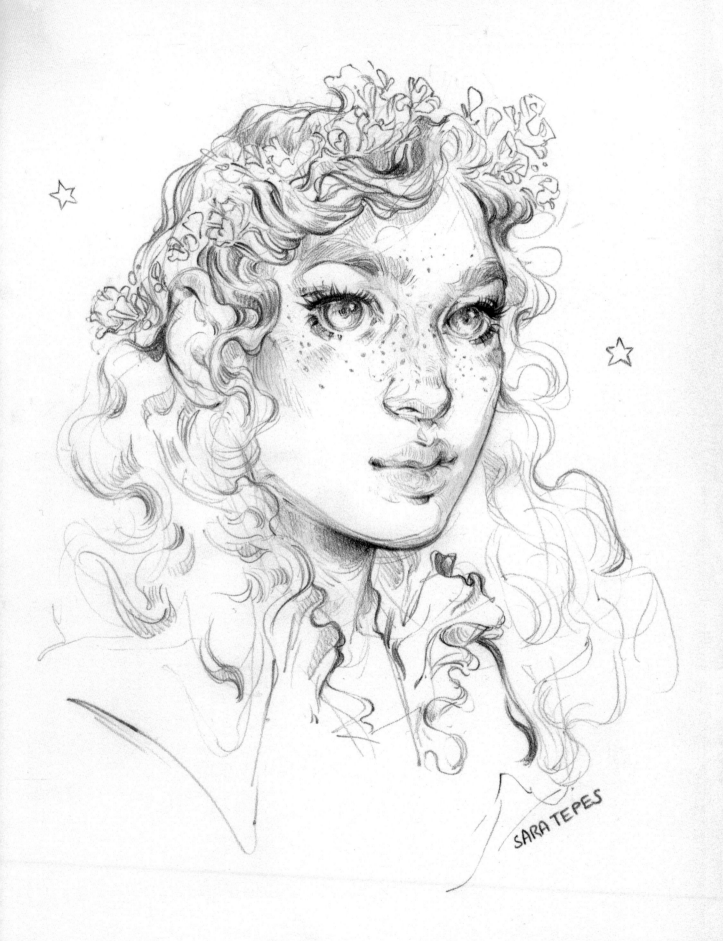

Woodland dragons

Mixed-media creature
design with Katie Thierolf

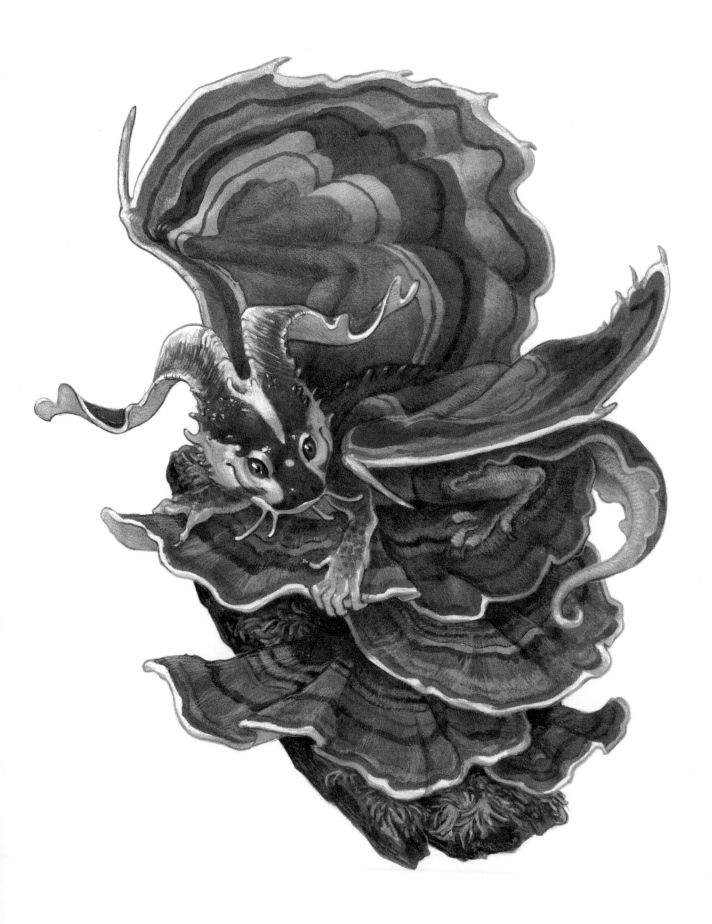

Join illustrator Katie Thierolf in creating a fungus-inspired dragon design with Prismacolor pencils, ink, and watercolors.

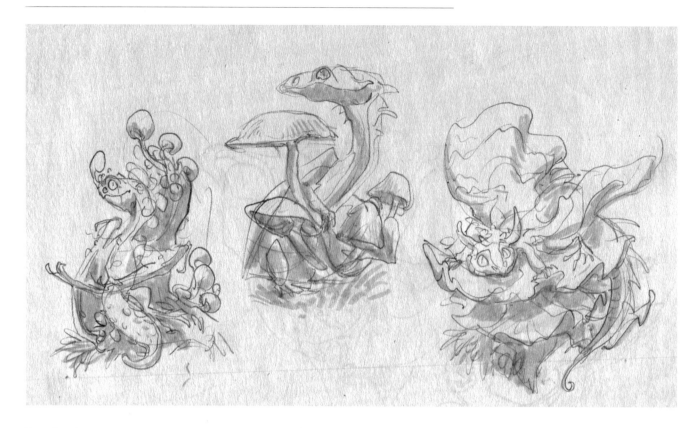

Inspiration

In this project I will be adding a new face to an illustration series of mine: "dragon fungi mimics." I have been using these nature-inspired creatures as a playground for my mixed media techniques for years, and this is my most recent take on the process. This series has been ongoing for years, so it's easy for me to find a starting point: what sort of fungi have I seen lately? Is there a type that I have tried to draw in the past, but failed to do justice? My thoughts go to *Ganoderma spp.* and *Trametes spp.* The former is almost like a living jelly roll, and the latter is a far more familiar sight, sometimes known as "turkey tail" or "hen-of-the-woods."

Studies

Over the past few months I have been making small fungi field studies which have helped inform my studio work in various ways. It is always a little easier to break down a problem if you can refer to a method you have tried in the past. How did I capture that texture in the field? What color does that odd sheen really appear as? A landscape painting teacher of mine often joked that a bad photo taken alongside a painted study is the best reference an artist can ask for: it may be a photo, but it's not so good that you're copying it exactly!

Head explorations

Fleshing out a reptilian/amphibian design is a familiar stomping ground for me, and thus I know my own habits: I tend toward stumpy, toad-like creatures with a leopard gecko's proportions. It's good to know your "thing," as this is likely what others know you by as well, and knowing it will give you a perfect springboard for innovation. In this progression of studies, I start out in my typical wheelhouse before realizing that I haven't yet designed a fungi mimic with a salamander face or any kind of complex facial markings. I sketch out ideas for the creature's head, mixing and matching photo reference of various reptile species to inform each face's shape, details, and markings to ground the sketch in reality.

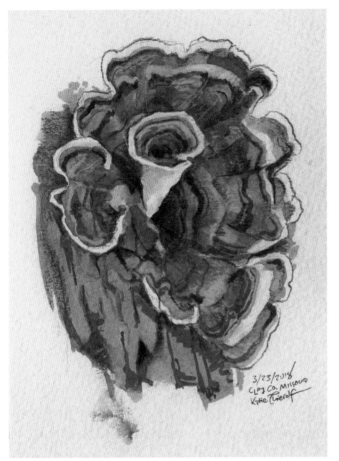

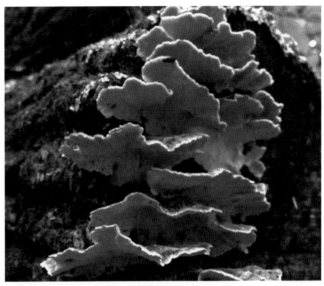

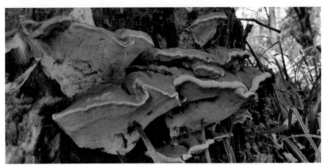

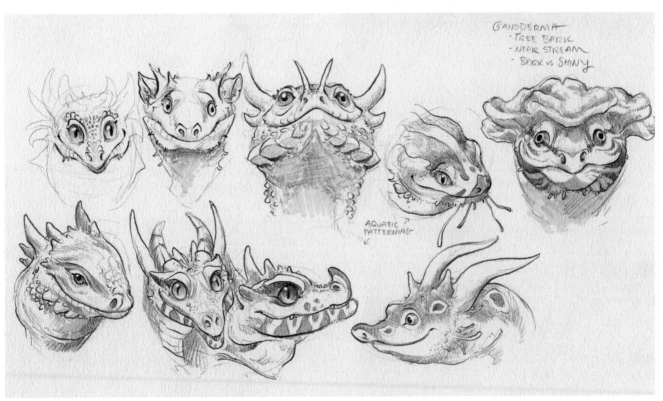

GANODERMA
- TREE BARK
- NEAR STREAM
- BARK vs SHINY

AQUATIC
PATTERNING

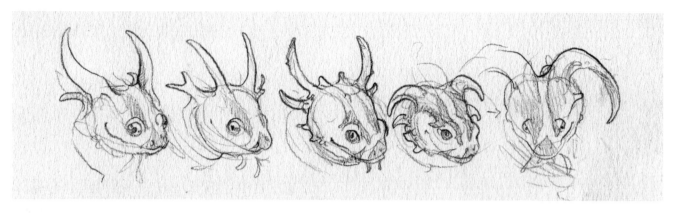

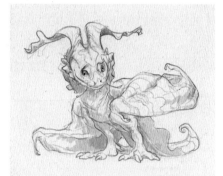

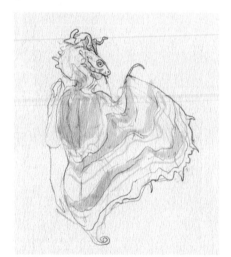

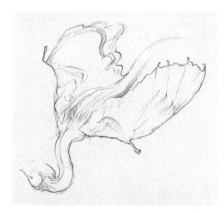

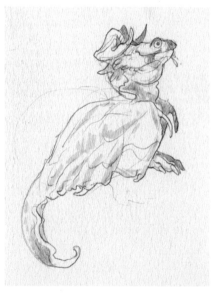

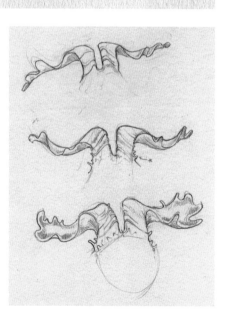

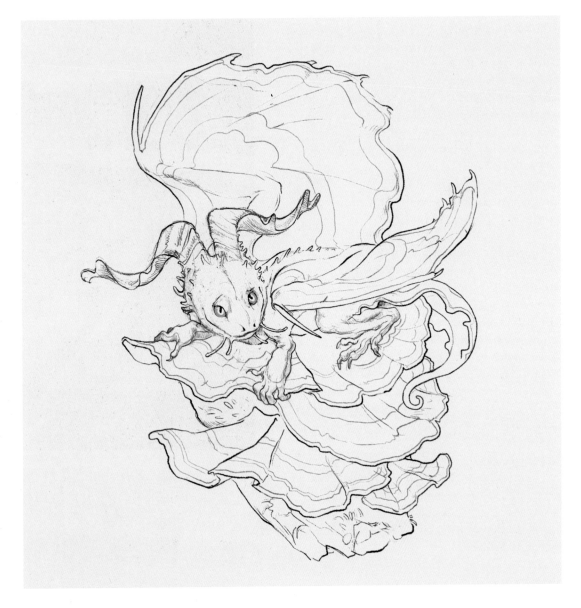

Anatomy sketches

Next I try to explore each piece of the mimic's anatomy individually, working out how the animal moves about in the world. My initial ideas involved the dragon being more aquatic in nature, but I settle on a combination of a typical terrestrial lizard and a bat (particularly for the wings).

I knew I wanted the mimic to have horns from the start, and I eventually settle on horns similar to a Bilberry goat's in shape. This combines well with the wavy nature of the turkey tail fungus. At first I am uncertain of how many legs the design should have, but

the final sketch ends up including a pair of front legs. My reasoning for this is that the position of the wings won't allow me to show off much of the hind legs.

Almost all of this preliminary work is drawn in a combination of ballpoint pen, graphite, and brush pen on paper. Smoother papers are far friendlier to the longevity of markers or brush pens.

Drafting

At this point in my process, I have come to use digital art programs as my primary drafting tool. I scan all of my sketches and

begin stitching my favorite parts together, stretching, skewing, mirroring, and drawing on top of them to create something cohesive.

All of this can be can be recreated traditionally with a stack of tracing paper and an opaque projector or light box, but in a work environment speed is often of the essence, and digital tools deliver in this regard. I use Adobe Photoshop CS6 and a Wacom Intuos III tablet that's old enough to drive in most US states, but you can use any image-editing program and tools. This part of the process should be loose and messy as you work out the final composition.

Watercolor supplies

My paper of choice is Fabriano Artistico hot press watercolor paper, 140 lb or heavier so that stretching the paper is not strictly required. However, if you tend to work with heavy, wet washes, I recommend stretching or stapling your paper, or perhaps working off a watercolor block to keep your paper in check. Cutting from a large sheet of paper is my preferred choice for the versatility in paper sizes, rather than buying a book or block. I cut an 8" × 10" (20.3 × 25.4 cm) sheet for the piece, with a 1" border all the way around to aid in future framing and matting.

This particular composition will be without a background, so I don't need to tape around the edges to keep them clean. If I was doing so, I would typically use an artist tape with no acidity and low adhesive. In the past, I used brightly colored tape (because it's pretty), but having those colors in close proximity to a piece negatively influenced how I treated the final image. I would end up subconsciously working the bright colors into a piece that didn't need them! If you are taping your paper down, opt for a neutral-colored tape if you can find one.

Testing colors

A few months prior to this project, I made a color-mixing chart for all of my watercolors on a whim, and it has come to my rescue multiple times since then. I highly recommend making one for yourself – you can see it in the background of my workspace on the right.

Use your mixing chart and some tiny print-outs of your final sketch to plan the color scheme of your image. It helps to use your worst brushes, or at least ones that you are less familiar with, to prevent you from getting too fiddly in your color tests. I cannot stress enough the importance of doing these tests on the same surface you'll be using for your final painting!

The coloration for this mimic is inspired by my past observations of the turkey tail fungus: deep crimson at the base, and grayish bands of color toward the outside. Perfecting that desaturated purplish-black base color is at the forefront of my mind as I paint. In the past, I have often fallen victim to over-saturating parts of my paintings which would have been best left alone, so now I make a very conscious effort to avoid overdoing my color schemes.

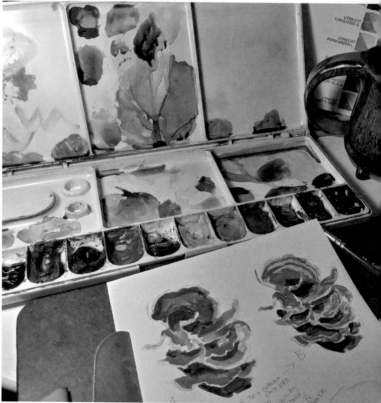

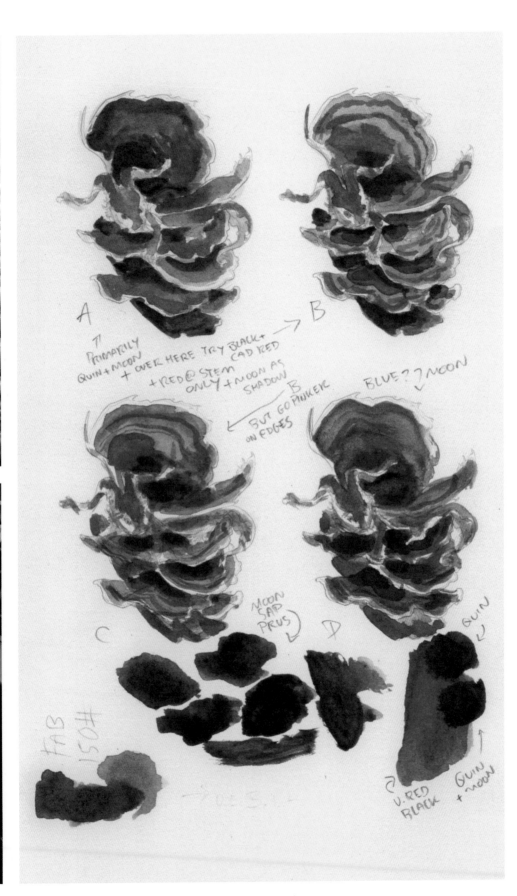

Far top left
The mix of pencils,
pens, and watercolors
used for this project

Far bottom left
To find your desired colors
more easily, it can be
useful to make your own
watercolor mixing chart

Near left
Exploring and comparing
color palettes and pigments
for the final piece

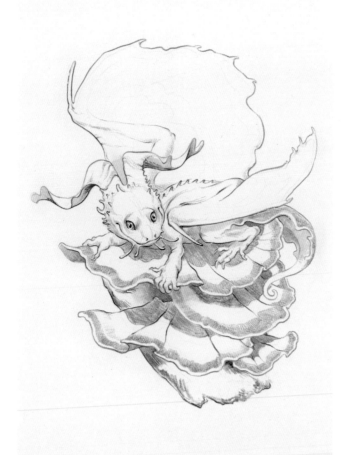

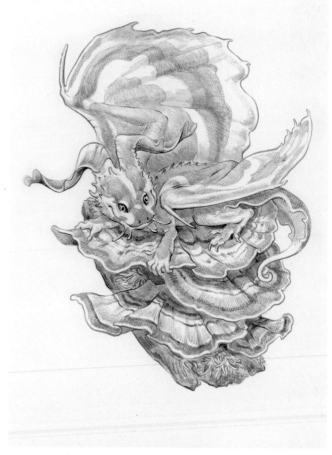

ARTIST'S TIPS

Fountain pen inks

I began sketching with fountain pen ink (such as Noodler's El Lawrence) during one of my field excursions, and after careful research I have begun using the ink for finished artwork. As much as I adore fountain pen inks, I tend to warn against using them for archival purposes due to their unpredictable nature: some are made in small batches, and supplies may vary by bottle or disappear. Most are dye-based and fade when exposed to light, and the majority lack water resistance. These won't be for you if you prefer a dependable, stable art supply in your arsenal. However, there are exceptions, and if this piques your interest, it's possible to find "bulletproof" fountain pen inks to suit your work. The online fountain pen community is full of knowledgeable people putting inks through any kind of water- and light-resistance test you can imagine, and information is easier to find than ever.

Prismacolor pencils

Prismacolor was the first artist-grade brand I learned to use when I was younger, and I've yet to find another brand that suits me so well. My favorite colors are Espresso PC1099 (for the majority of my line work), Tuscan Red PC937 (the best rich, dark red), Mineral Orange PC1033 (I admit to over-using this), Limepeel PC1005, and Indigo Blue PC901 (perfect for creating deep, dark, faux-black burnished areas when paired with umbers and browns).

Above
The base drawing with Prismacolor colored pencil and Tombow brush pen for value and flavor. Only the very darkest parts of the sketch are touched with a bit of dark ink

Near right
The pencil drawing with the first pass of watercolor applied

Far right
Continuing to apply watercolor washes, waiting for each layer to dry

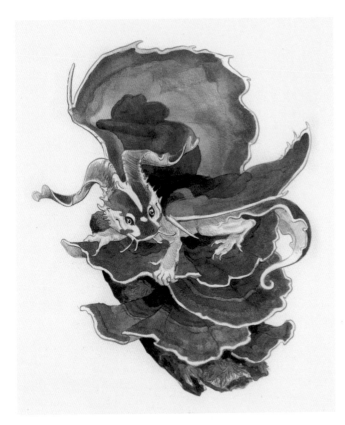

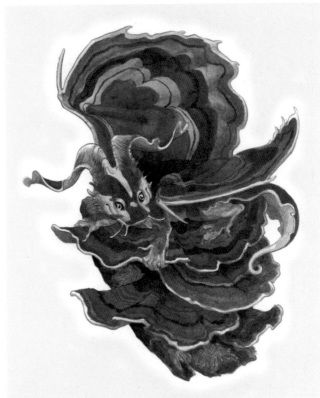

Final line work

After using a transfer method of choice (lightbox, graphite transfer, or lightly printing the lines onto paper), we can start creating the colored pencil line work. Keeping in mind the general colors and values, I start to draw far darker and more saturated than it feels like I should; I have learned from experience that most of this detailing will be lost in the watercolor washes that follow. I use Prismacolor pencils, which are very waxy pencils, aiding in layering, burnishing, and water resistance. Once this step is complete, I make sure to scan the pencil drawing in order to preserve it; this way it can be used as a base for digital color if the traditional art is damaged, or if the client desires drastic (or more easily changeable) color alterations.

I use a fountain pen ink called Noodler's El Lawrence on the dragon's pupils, eye ridges, and edges of the mouth. Fountain pen inks tend to be unpredictable and come with a handful of caveats (see the tip box on the left), so if you aren't intimately familiar with

a particular ink, I would recommend using a Micron or similar reliable, archival technical pen. This piece will be too light and orange-based for it, but on previous darker pieces I have used heavy washes of Noodler's El Lawrence to establish shadow and create more permanent mark-making before the watercolor wash.

I make a last-minute change to the shape and location of the mimic's pupils, removing the direct eye contact with the viewer; the unfocused, almost fish-like eyes are suitably bestial, alien, and more "animal."

First watercolor pass

I apply the first careful washes of watercolor directly onto the pencil lines without fixative, following the orange-brown color scheme I explored earlier. Just five minutes into painting this piece, I am already thinking of new approaches and things I could try next time. It's so important to keep ideas fresh in your mind, never letting your artistic muscles atrophy. Making a texture study or two might

seem futile, but they *will* pay off in time, when you're working on a large piece and can tap into the experiences you have accrued.

Layering watercolors

I enjoy working with a wet-on-wet watercolor technique when the painting allows for it, but this piece requires quite a lot of wet-on-dry layering due to all of the striations. Similarly, I apply the dark colors of the bark onto the bright greens of the moss after the greens have dried. Daniel Smith's Quinacridone Burnt Orange is a new addition to my watercolor arsenal, and a key choice for the reds in the wings and fungus.

In my experience, hot press watercolor paper doesn't allow for as much lifting (re-wetting watercolor and lifting it away with the brush) as cold press, but you may be able to remove a small amount of watercolor if you make an area too dark. At this point in the illustration it is important not to overwork any one area; it's easier to know where you stand if the whole drawing is at the same level of finish.

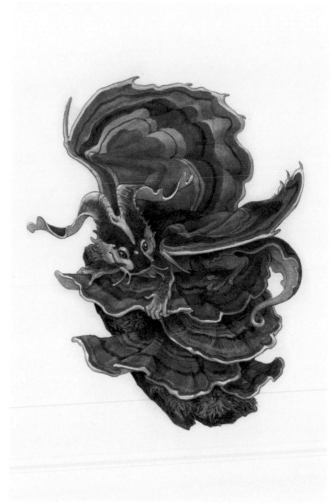

Shading with pencil

I go as far as I can using only paint before jumping in with pencils, keeping in mind that a foundation that's too dark is far better than too light in this context. Though it varies a little from pencil to pencil, light gray, green, and cream pencils look beautifully bold and opaque when layered on top of a dark base. The shadows are established and washed over the figure with watercolor, alternating with applications of colored pencil to enhance the form and adjust or correct the colors. I try to keep my palette limited, particularly the darker colors and shadows, in order to create cohesion in the finished piece.

My choice of watercolor as the "base" for my pencils comes down to preference. In the past I have experimented with using acrylics, gouache, brush pen, ink, marker, and different papers for a similar purpose. It was love at first sight with the hot press Fabriano paper, as far as surface goes, but I have also used vellum Bristol board and more recently a cheaper Bee Paper mixed-media book. However, I have found this particular combination of paint, medium, and paper texture leaves me feeling absolutely delighted whenever I sit down to work.

Revising the shadows

This is the stage where the illustration can get a little muddy. There can be a lot of trial and error involved, but the time invested in preliminary work and color studies helps to rein everything in. I had let the image's lighting become somewhat flat before a friend intervened and urged me to darken the dragon's hind legs and tail to re-establish the light source. What a difference a fresh pair of eyes makes! I apply watercolor to those areas, then a layer of matte fixative to improve the pencil layering in the next step.

Pencil detailing

Mark-making with pencils is key here, whether that means burnishing a bright red onto the dragon's face, creating the ridged surface of the fungi with long warm gray strokes, or using directional hatching to create form.

As I mentioned before, it's important to know your own habits: my brain skews towards warmth and yellow colors even if an illustration needs otherwise, so I work vigorously to emphasize the grays here.

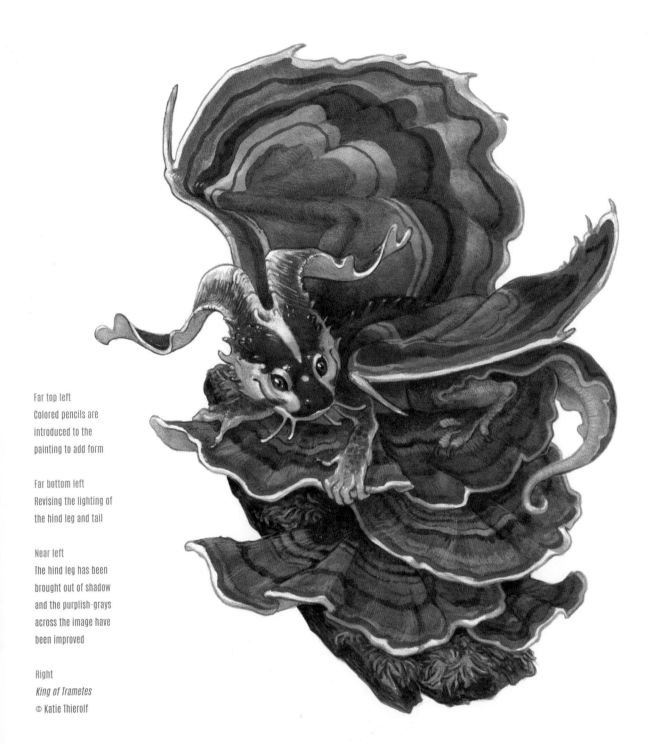

Far top left
Colored pencils are introduced to the painting to add form

Far bottom left
Revising the lighting of the hind leg and tail

Near left
The hind leg has been brought out of shadow and the purplish-grays across the image have been improved

Right
King of Trametes
© Katie Thierolf

The final image

After another coating of matte fixative, I apply a few touches of white acrylic paint to the focal point of the mimic's face, making the eyes and texture pop. During this last round of mark-making I work to accomplish color cohesion: the green of the moss is worked into the underside of the mimic's horns and cheeks to give the impression of bounced light, the red of the wings is slotted under the moss, and touches of indigo blue are added in equal amounts to shadows across the whole image. I also allow myself to use pure black and white colored pencils to give the shadows and highlights one final push. After declaring an illustration finished, I like to let it sit in the house for a day or two, allowing me to mull it over in passing to see if I've forgotten anything. After adding a signature and a final coating of matte fixative for protection, the image is complete.

CONTRIBUTORS

Joanne Nam
joannenam.com

Marie-Alice Harel
maharel.com

Nicolás Uribe
nicolasuribeart.com

Yorik van Havre
yorik.uncreated.net

Alexander L. Landerman
alexanderlanderman.com

Mickael Balloul
artstation.com/mickaelballoul

Maja Wrońska
behance.net/takmaj

Sara Tepes
instagram.com/sarucatepes

Katie Thierolf
katiethierolf.com

THE GRAPHITE TEAM

Marisa Lewis
Editor

Matthew Lewis
Graphic designer

Adam J. Smith
Proofreader and contributor
adamjsmithauthor.blogspot.co.uk

Simon Morse
Managing editor

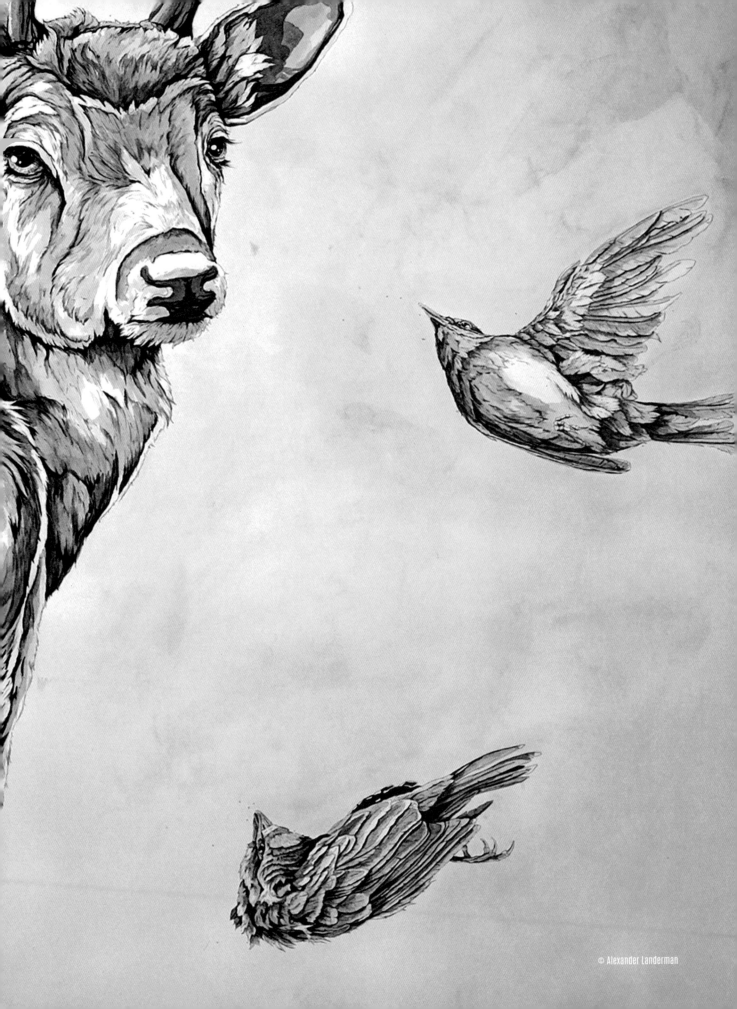